THE PERSISTENCE ● OF GEOMETRY

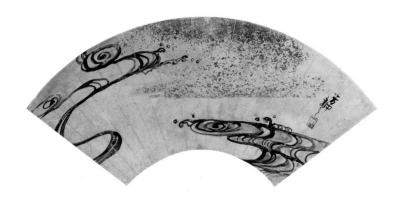

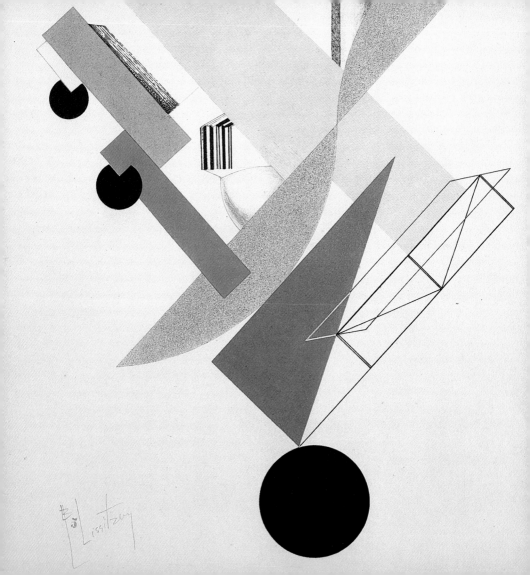

THE PERSISTENCE OF GEOMETRY

Lowery Stokes Sims

Form, Content, and Culture in the Collection of the Cleveland Museum of Art

The Cleveland Museum of Art

at The Museum of Contemporary Art Cleveland

9 June–20 August 2006

Cover:
Ellen Carey,
Constructivist Portrait
(detail), 1983 [123]

Frontispiece:
Nakamuro Hochu,
Waves (detail), late
1700s–early 1800s
[33]

Title page:
El Lissitzky, *Plastic
Figures of the
Electro-Mechanical
Show* (detail), 1923
[66]

Right: Frank Stella,
*Gray Scramble
(Single), VIII,* 1968
[108]

A Note to the Reader

Please refer to the catalogue of the exhibition and the figure list at the back of this book for more information about each of the illustrations. The numbers enclosed in brackets are catalogue numbers for works in the exhibition; comparative illustrations, or figures, are numbered consecutively and enclosed in parentheses. The catalogue of the exhibition lists works of art in chronological order. The credits list follows the list of figures.

The exhibition *The Persistence of Geometry: Form, Content, and Culture in the Collection of the Cleveland Museum of Art* was organized by the Cleveland Museum of Art in collaboration with MOCA Cleveland and made possible through generous grants from the Kulas Foundation and the John P. Murphy Foundation. Additional support was provided by The Contessa Gallery. The Cleveland Museum of Art and MOCA Cleveland receive support from the Ohio Arts Council.

9 June–20 August 2006 at MOCA Cleveland

ISBN: 0-940717-86-7
Library of Congress Control Number: 2006925227

Produced by the Publications Department of the Cleveland Museum of Art.
Editing: Barbara J. Bradley and Kathleen Mills
Design: Thomas H. Barnard III
Production: Charles Szabla
Printing: Great Lakes Integrated, Cleveland

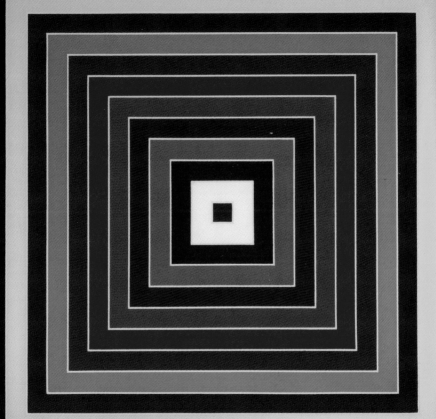

Board of Trustees

Peter Carl Fabergé,
*Frame with Nine
Miniatures,* 1896–
1905 [51]

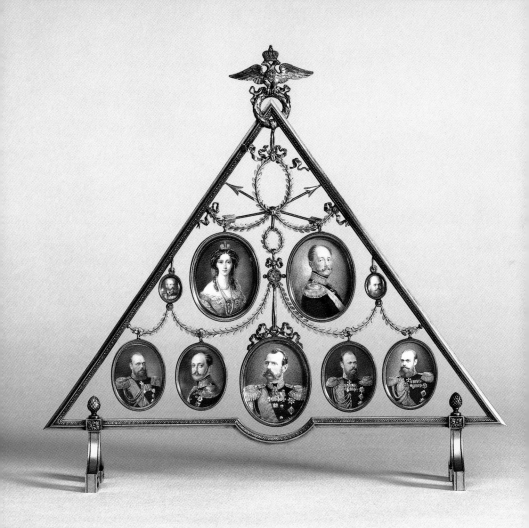

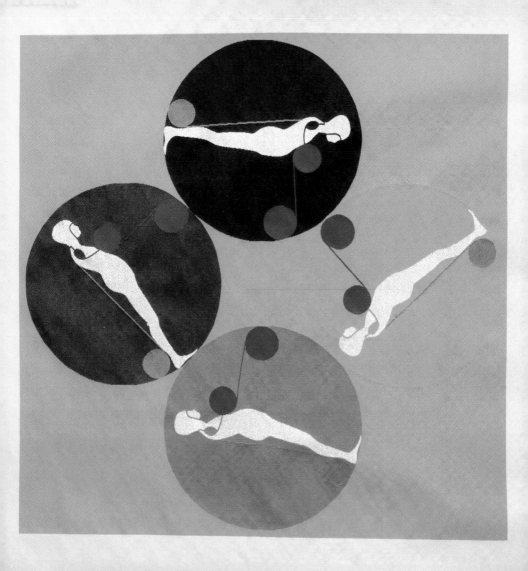

Contents

Ernest Trova,
*Falling Man/
Canto T,* 1970s
[109]

Foreword

When expansion of the Cleveland Museum of Art dislodged some 40,000 objects they became available for fresh assignments. Jill Snyder, director of the Museum of Contemporary Art Cleveland, and CMA Deputy Director Charles L. Venable initiated an exciting experiment: MOCA would become an exhibition venue for objects from the museum's collection, and allow our stately institution to collaborate with a lively contemporary art organization. Jill and Charles offered the distinguished scholar Lowery Stokes Sims the entire CMA collection as material for an exhibition, hoping that she could not resist this invitation. Dr. Sims did not disappoint them.

Though most often noted for passionate interest in the work of African-American artists, Lowery Sims is also the author of influential studies of many others, such as Wifredo Lam and Stuart Davis. Through their work runs an interest in abstraction, but not the doctrinaire formalism championed by Clement Greenberg. Sims's artists engage experience beyond the visual, whether issues of social justice or personal psychology. They embrace abstraction as an assertion of freedom—from convention, from illustration, from social oppression—and an opportunity to concentrate on the emotional potential of

form and color. Those for whom figuration remained indispensable, such as Lam and Elizabeth Catlett, also developed rigorous formal vocabularies. These artists share with their interpreter a vital engagement with the world and the ambition to address universal themes. They also eschew polemic, refusing the familiar tropes of social debate and insisting on individual self-expression. The viewer is addressed as an individual sensibility, not as a member of a group.

The exhibition expands this inquiry to examine a language of universal form, a neural pathway that connects the imaginations of artists and viewers through the ages and around the world. We might say that the exhibition relates to Dr. Sims's career as a gnomon does to a geometric form, an addition that increases the size of the form without changing its shape. From the interpretation of individual artists she has turned to the study of the expressive potential of geometry across the widest possible spectrum. Not only does this inquiry transcend the conventional hierarchies of a museum—the privilege often accorded Western painting over the decorative arts, for example—but also the categories of culture and ethnicity.

From this perspective, all cultures may be seen as expressions of a common humanity, which the exhibition invites us to experience in an intimate, personal way. No enterprise could be more timely, or more welcome in Cleveland.

Timothy Rub
Director, The Cleveland Museum of Art

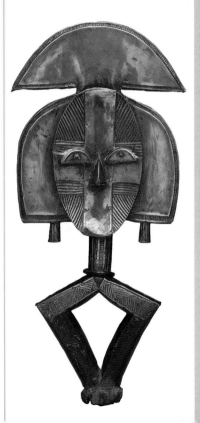

Gabon, Kota people, *Reliquary Guardian Figure*, 1800s [34]

Preface

Both our organs of perception and the phenomenal world we perceive seem to be best understood as systems of pure pattern, or as geometric structures of form and proportion.

—Robert Lawlor, *Sacred Geometry*

Geometry can be found all around us. While we tend to associate it only with the diagrams and formulas we coped with in high school mathematics courses, in fact geometry forms the basis of the spaces we inhabit, the contours around us, the patterns that delight our eyes, the mapping we do of terrestrial and cosmic positions, and even the rhythm of our lives.

The Persistence of Geometry: Form, Content, and Culture in the Collection of the Cleveland Museum of Art is an exploration of the visualization of geometry and geometrical forms through history with a special emphasis on modern and contemporary art. It is a highly personal visual journey that draws on the encyclopedic collection of the Cleveland Museum of Art. The selection has been shaped by considerations of time, commitments to other exhibitions, the physical condition of works, and the capacity of the gallery space at the

Museum of Contemporary Art Cleveland where this exhibition is installed.

I wish to thank Charles L. Venable, deputy director for collections and programs at the Cleveland Museum of Art, and Jill Snyder, director of MOCA Cleveland, for this extraordinary opportunity. It has been a challenge and a joy. Among the helpful staff

Central Europe, Bronze Age, *Spiral Armilla*, c. 1500 BC [3]

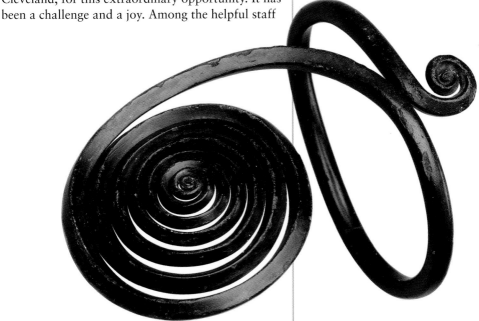

Manierre Dawson,
Differential Complex (detail),
1910 [57]

of the CMA, I am also indebted to Tom E. Hinson, curator of photography, and Robin Koch, curatorial assistant. Heidi Strean, director of exhibitions, and Morena L. Carter, exhibition coordinator, were my guides and coordinated every detail of this project. Thank you also to Laurence Channing, director of publications, and Barbara J. Bradley, senior editor, for their patient stewardship of the catalogue and to Thomas H. Barnard III, senior graphic designer, for his wonderful design concept. Andrew Gutierrez, exhibition designer, seemed to read my mind every step of the way in the conceptualization of the installation, completed in record time by Jeffrey Strean, director of design and architecture, and his staff; Bruce Christman, chief conservator, and his staff; Mary Suzor, chief registrar, and her staff; and much help from editor Jane Takac Panza. Wherever possible, the advice and consent of the curatorial staff of the CMA—the dedicated stewards of the collection—have been sought and generously given. I thank them for the privilege of "invading" their turf and reworking it with an outsider's eye. I hope that what emerges is a record not only of the commonalities of human perception throughout the ages and in different cultures, but also of the continuing dialogue of vanguard art from the 19th, 20th, and 21st centuries with traditional and historical art.

Lowery Stokes Sims
Guest Curator

Introduction

40,000 Years of Modern Art: An Approach and Methodology

It is a well-known fact that the art of traditional cultures in Africa, the Americas, the Pacific, and Asia had a seminal and generative impact on the pioneers of modernism. But for the most part modern and contemporary art theory has relegated this art to a secondary status as mere sources of motifs for vanguard art.

The conceptualization of this exhibition was influenced by two projects in the history of 20th-century art. The first is the idiosyncratic 1931 publication *Foundations of Modern Art* by the French artist Amédée Ozenfant.[1] The second is the 1947 exhibition *Forty-thousand Years of Modern Art,* organized at the Institute of Contemporary Art in London by the English poet, critic, and essayist Sir Herbert Read,[2] photographer W. G. Archer, and aficionado Robert Melville.[3] *Foundations of Modern Art* was written to explain modern art to a general audience. Ozenfant not only documented the various movements, he also emphasized the continuity of modern art by demonstrating how geometric forms such as circles, squares, and triangles have figured in all art, in all cultures throughout human history. That he saw these forms as constituting the underlying geometry of life was predicated on his own association

with the art movement known as Purism. The other adherents to this movement—painter Fernand Léger and architect Le Corbusier (Charles-Édouard Jeanneret)—focused on "mathematical order, purity, and logic" through a "precise arrangement modern, impersonal, 'universal' forms, especially images of simple machine-made objects from everyday life."[4] This sensibility is amply captured in Léger's 1920 painting *Aviator* (fig. 1) in the museum's collection, which is dominated by a circular form that evokes an airplane propeller and features a robot-looking human figure subsumed within a composition of pristine two- and three-dimensional shapes.

Read, Archer, and Melville, like Ozenfant, were also interested in how "archetypal," "unconscious" conditions reveal themselves in the world as shapes and patterns.[5] *Forty-thousand Years of Modern Art* demonstrated further how modern art drew on sources from a broad sweep of world art. This strategy affirmed the "universality of art, and, more particularly, the eternal recurrence of certain

Fig. 1. Fernand Léger, *The Aviator*, 1920

phenomena in art, which on their appearance, are labeled 'modern'.[6] The reason, postulated by Read, Archer, and Melville, was that in the course of human history "like conditions produce like effects, and, more specifically . . . there are conditions in modern life which have produced effects . . . seen in primitive epochs."[7] These conditions often prompted "expression in abstract or un-naturalistic forms."[8] "Therefore," as Robert Lawlor notes, "when many ancient cultures chose to examine reality through the metaphors of geometry and music . . . they were already very close to the position of our most contemporary science."[9]

The transnational and ahistorical approaches of these two projects are particularly pertinent for our time. Since the 1970s social and cultural constructions such as diversity and multiculturalism have transformed the critical and theoretical landscape. These changes were stimulated by, and have been accompanied by, the growing presence of cultures outside Europe and the United States in the world art scene. Consequently, cultures formerly considered peripheral to the discourse dominated by Europe and the United States have been propelled into the center of that dialogue and are now considered integral and distinct contributors to the highest manifestations of human intellect, creativity, and production. Some in the intellectual and cultural communities view these developments as a breakdown of a sense of common experience and identity. *The Persistence of Geometry,* however, provides an opportunity to understand forms and shapes as carriers of meaning that are both specific to a particular cultural context and universal in their immediate appeal.

Egypt, Predynastic period, *Squat Jar with Lug Handles* (detail), 4000– 3000 BC [1]

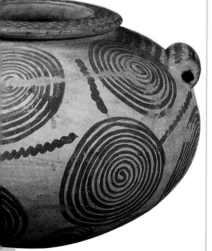

The Persistence of Geometry not only presents works of art outside the usual hierarchical positioning that privileges "Western/European" over "tribal," "primitive/non-Western" art, it also seeks to bypass the usual positioning within Western/European art theory of high art (that is, painting, sculpture, drawing, and printmaking) over decorative or applied art. The works in this exhibition date from the Neolithic and Predynastic periods in China and Egypt to the contemporary period in New York City. They embrace circles, squares, diamonds, rectangles, triangles, hexagons, octagons, and pentagons as well as arcs, swirls, and "cubic, spherical, and pyramidal components."[10] The criteria for inclusion in the show were that each work of art manifest a self-conscious act of decoration and that the "flat pattern of lines and shapes" function as "an important aspect of design, even for those painters concerned with creating illusions of great depth."[11] Consideration was also given to elements such as symmetry, the character of lines ("smooth or jagged, rounded or angular, freeform or meticulous"), the sense of pattern in repeating shapes, and the role of color "in evoking specific emotional and psychological responses in the viewer."[12] Although we will be able to "discern elements of Pythagorean mathematics . . . in the composition and design" of the objects in this exhibition, more often than not such effects "may have been created more by intuitive judgment than by calculated measurement."[13]

Ellen Gallagher,
Bouffant Pride
(detail), 2003
[143]

1 Shapes and Planes

What is important here is that Magdalenian art or Negro art, by means of plane or curved masses, straight or broken lines, colour, various substances specially related, directly affects us, in the same way that Michael Angelo's "Moses" powerfully affects the Negro, although the latter understands nothing of the former's symbolic intentions, nor we those of prehistoric man or the Negro.

—Amédée Ozenfant, *Foundations of Modern Art*

Geometry is defined as the "branch of mathematics that deals with the measurement, properties, and relationships of points, lines, angles, surfaces, and solids" as well as "the study of properties of given elements that remain invariant under specified transformations." Additionally, elements such as "configuration," "surface shape," and "an arrangement of objects or parts that suggests geometric figures" are included as well as the phenomenon of "increasing in a geometric progression," as in the case of "population growth."[1] Definitions that specifically relate to art, such as "of or relating to a style of ancient Greek pottery characterized by geometric decorative motifs," are also understood and any act of "utilizing rectilinear or simple curvilinear motifs or outlines in design," or "of or relating to

Egypt, Byzantine period, *Roundel from a Curtain* (detail), AD 300s–400s [12]

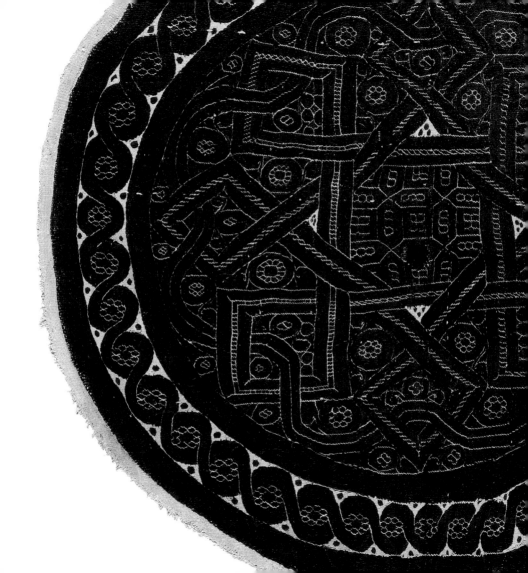

art based on simple geometric shapes (as straight lines, circles, or squares)," which can include more contemporary examples such as "geometric abstractions." These definitions indicate the broad territory that geometry in art can traverse.

The first experience of geometry a visitor has at the Cleveland Museum of Art is through the building the museum occupies. Renderings of the original structure with the successive additions by architects Marcel Breuer (1971) and Rafael Viñoly (2005–10)

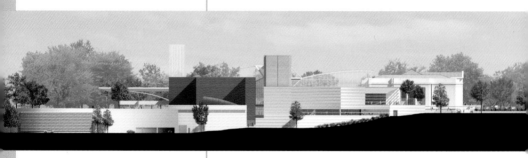

Fig. 2. Rafael Viñoly, Cleveland Museum of Art, west elevation

(fig. 2) combine classically inspired elements with the volumetric structures of modernism and postmodernism. The triangular pediment and cylindrical columns of the original Beaux Arts entrance (fig. 3), which faces south, announce the museum as an important civic space, sharing architectural details with structures such as libraries, town halls, post offices, and courthouses. This architectural style is an American adaptation of classical architecture such as the Pantheon in Rome (fig. 4), whose interior is captured in the 18th-century painting by Giovanni Paolo Panini [29] in the museum's collection. Just as the Pantheon served as a place of

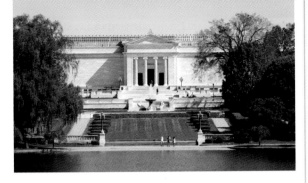

worship for two distinct sects in two different time periods—a Roman temple and an early Christian church—museums are now considered comparable sites of contemplation and edification.

The simple geometric forms of the Breuer addition, visually activated by the horizontal striated design, speak to the museum's engagement of modernist architectural language, particularly that practiced by the venerable Bauhaus school. When Viñoly's vision becomes a reality, the Cleveland museum will be a marvel of interconnected boxes and rotundas—seen especially in the western elevation—that celebrate expansiveness, while the rectangular and vertical elements serve as beacons that can be glimpsed from a distance.

The museum tower as a beacon recalls the campanile in the Piazza San Marco in Venice, as seen in the works by Francesco Guardi [32] and Bernardo Bellotto (fig. 5). These views demonstrate both the symbolism and the practicality of geometry in cityscapes. Although the piazza in Venice is a "square" in the sense of its function as a public space, its actual configuration is a trapezoid that conveys the

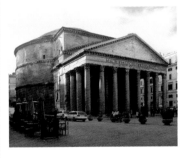

Fig. 4. Exterior view, Pantheon, Rome

impression of a square. Such illusions were well known in antiquity, and the slightly different vantage points of the Guardi drawing and Bellotto painting convey the vast, yet intimate, character of a space that is framed on three sides by a three-tiered colonnade that plays off the geometric shape of the square. The verticality of the campanile provides a visual accompaniment to the great arches that dominate the Byzantine facade of the basilica itself.

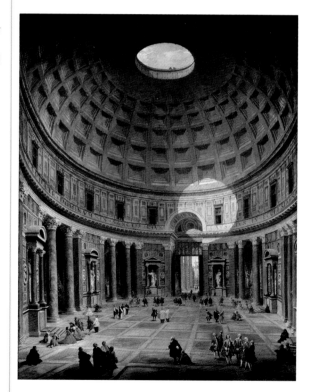

Giovanni Paolo Panini, *Interior of the Pantheon, Rome,* 1747 [29]

Originally bifurcated by a canal, the Piazza San Marco in its current configuration was created in the 12th century. Thinking about how different the experience would have been in such a space leads to pondering the importance of proportion and its importance to the consideration of geometry. This "emphasis upon the proportion of the parts to the whole"[2] can be found in the artistic theories, symbology, and practice of many cultures. One of

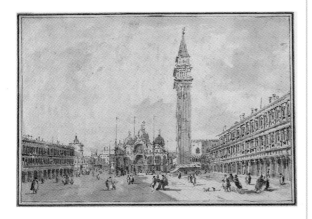

Francesco Guardi, *Piazza San Marco, Venice*, 1780s [32]

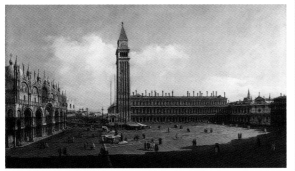

Fig. 5. Bernardo Bellotto, *Piazza San Marco, Venice*, c. 1740

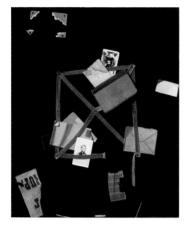

John F. Peto,
*Card Rack with
a Jack of Hearts,*
c. 1895 [49]

the best known is that of the Golden Section, a system of "ideal" proportions "on which to base the framework of lines and shapes in the design" of a work of art.[3]

This phenomenon of visual balance that is inherent in the system of the Golden Section can be observed in John F. Peto's *Card Rack with a Jack of Hearts* [49], painted in the United States around 1895. The viewer is similarly engaged by the skillful arrangement of the rectangular elements and Peto's balance of the different color shapes in whites, greens, and blues. The composition is known as a "rack picture," and this tour de force of illusionistic painting features an *X* within a square pattern of cloth tape that anchors the various letters, notes, photographs, and playing card to a wooden board. Despite its date, this work conveys a surprising modernist impression in its relative lack of perspective and emphasis on the flat plane of the wooden

Dorothea
Rockburne, *White
Mozart,* 1986
[125]

Dorothea
Rockburne, *White
Mozart, Upside
Down and
Backwards,* 1986
[126]

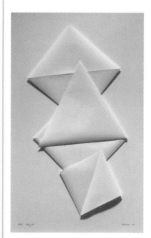
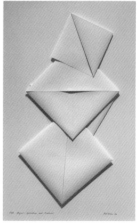

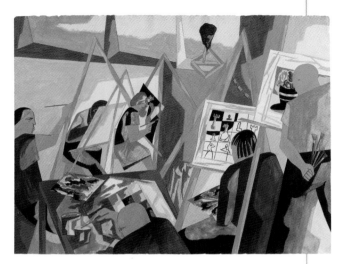

Jacob Lawrence,
Creative Therapy,
1949 [87]

board. Dorothea Rockburne's 1986 *White Mozart* [125 and 126] demonstrates the persistence of such ideas even into the 20th century. Associated with trends in Minimalist and reductive imagery in the 1960s, 1970s, and 1980s, Rockburne has drawn on the concept of the Golden Section in her work, and here we can ponder the relationship between the squared elements and the folding that sets up the proportional relationship between the parts and the whole.[4] In Jacob Lawrence's *Creative Therapy* of 1949 [87] the space is tilted upward and dominated by the repetitive triangular open frames that intersect with the planes of the canvases.

Among geometric shapes the circle is perhaps the most empathetic. Both static and mobile, it is a particularly embracing form signifying unity, infinity, chance, and fortune. From earliest time the circle was the site of rituals, especially marking the course

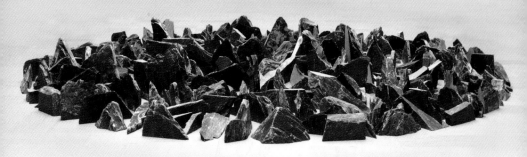

Richard Long,
Cornwall Circle,
1991 [132]

of the sun and the stars. Richard Long's *Cornwall Circle* [132] of 1991, composed of large and small pieces of slate, reminds us of such circular monuments from Stonehenge in England to the Big Horn Medicine Wheel in Wyoming. The sun, moon, and planets are spheres—three-dimensional circles; in *Small Worlds*, a 1922 woodcut by Russian avant-garde artist Wassily Kandinsky [64], a suggestion of planets and meandering lines intersect with a rectangular plane that evokes a nebula or concentration of cosmic dust, over which appears a form that

Greece,
Boeotian, *Fibula
with Solar Design*,
700–675 BC [8]

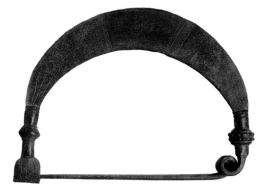

might be a telescope. The arc of the form of a fibula with a solar design from Greece in the 7th to 8th century [8] mimics the movement of the sun across the sky in the course of a day. In Adolph Gottlieb's untitled drawing of 1965 [103], a black disc hovers over a discrete mass of chaos—his signature statement. That this work refers to cosmic phenomena may be a matter of conjecture, but it does invoke the duality of order and chaos, sun and earth.

The movement of the sun and planets signals cycles of light and dark, seasonal changes, the repetitive rhythms of the universe. In the 12th-century bronze sculpture *Nataraja, Shiva as the King of Dance* [17], the Hindu deity dances within a large circle suggesting the cyclical nature of life. The flames encircling the halo symbolize the cycles of

Wassily Kandinsky,
Small Worlds: VI,
1922 [64]

Adolph Gottlieb,
Untitled, 1965
[103]

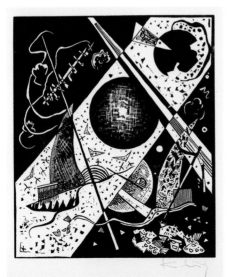

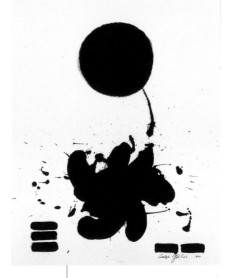

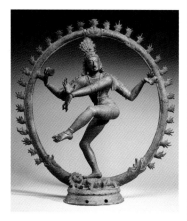

South India,
Chola period,
*Nataraja, Shiva
as the King of
Dance*, c. 1100
[17]

destruction and recreation of the universe.[5] In the Tibetan votive painting *Preaching Sakyamuni* [15] from the 11th century, the Buddha is seated within a circular mandala that embodies the concepts of community and connection and is similar to the Christian symbol of the halo, a holy presence. The Wheel of Dharma symbolizes the concept that the teachings of Buddha will spread all over the earth throughout all time.[6] Islamic thought introduces ocular associations, where it is seen as the "gateway" to the soul.[7] The roundel with interlacing knot from a curtain made in Egypt in AD 300s–400s [12] protects against evil—against what is more familiarly known as the "evil eye."

Western Tibet,
Toling Monastery,
*Preaching
Sakyamuni*,
1000s [15]

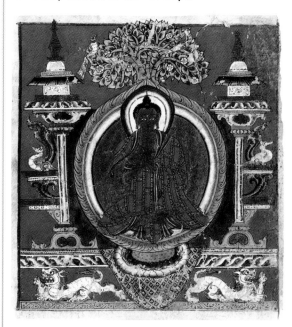

Ernest Trova draws us into an existential mode in his 1970s tapestry *Falling Man/Canto T* [109]. Four of his signature featureless and armless humanoid figures are arranged within as many blue, purple, gold, and orange circles; their helter-skelter positioning justifies the image of disequilibrium conjured by the title. The figures share their circles, front and back, with plumb lines ending small circles and S-shaped configurations. The figures are set in different positions that appear to isolate different moments of a turning maneuver so that the entire composition reinforces the circle as a wheel of fortune or fate. The question is whether the hapless figures can break free from the seemingly uncontrolled, inevitable movement.

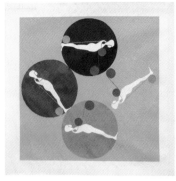

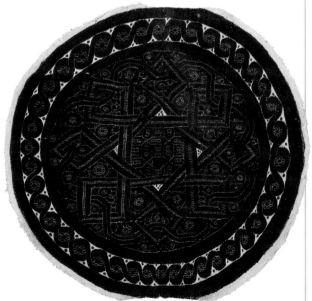

Egypt, Byzantine period, *Roundel from a Curtain*, AD 300s–400s [12]

Ernest Trova, *Falling Man/ Canto T,* 1970s [109]

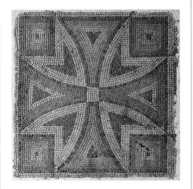

Byzantium, North Syria, *Floor Mosaic Panel with Cross,* AD 300s–400s [11]

The cross, a particularly versatile shape, is a potent symbol as well as a form involving interwoven elements. Its most familiar emblematic role is representing the crucified Christ, as seen in a Byzantine mosaic from Syria dated AD 300s–400s [11]. The cross is set on a square slab that complements its overall form. As in Greek crosses, the arms are of equal length; the arrow-shaped elements whose points meet at the square in the center create an X-shape similar to what is known as St. Andrew's Cross.[8] As a shape, the cross has a long history, representing laterally the crossroads of two byways and vertically the intersection between heaven and earth.

On a small but intense Asante soul washer's badge from the late 19th century, the cross presents a radiating pattern [36]; arcs encircle a central knob on an other Asante badge [35]. Such disks, which represent the sun, are worn by members of the ruling class for protection.[9] In this context we can also consider that a disk with a cross in a circle is associated with a "sunwheel," "solar cross," or "Odin's cross" in Norse culture. It can also signify the cardinal directions (north, south, east, and west) or the four elements (earth, air, fire, and water).[10] In Fritz Glarner's 1949 painting *Tondo, No. 12* [86], which

Ghana, Asante people, *Soul Washer's Badge,* 1800s [35]

Ghana, Asante people, *Soul Washer's Badge,* 1800s [36]

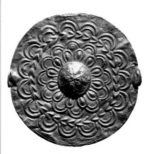

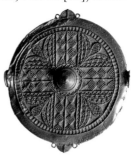

was inspired by the De Stijl movement, the interconnected white, red, blue, and yellow bands defy the strict dictates for a flat, horizontal/vertical orientation of elements that are characteristic of the movement. Glarner introduced a sensation of successive layers of space in the alternating, overlapping, and irregular bands of color whose simulation of basket weaving conveys a strong cruciform pattern. The ubiquitousness of the cross motif can also be seen on objects such as an 8th-century BC geometric bird askos [9], where it is interspersed with "checkerboards, zigzags, and crosshatched triangles [that] coexist with more representational images within a unifying framework."[11]

Fritz Glarner, *Tondo, No. 12,* 1949 [86]

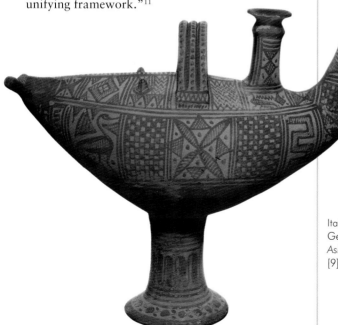

Italy, Italo-Geometric, *Bird Askos,* c. 700 BC [9]

Ghana, Asante people, *Weight for Measuring Gold*, 1800s [37]

Ghana, Asante people, *Weight for Measuring Gold,* 1800s [38]

Stuart Davis, *Composition Concrete (Study for Mural)*, 1957– 60 [96]

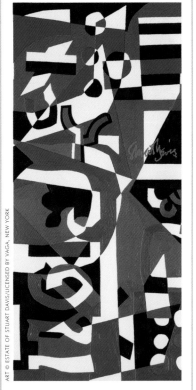

Other objects demonstrate more complex geometric forms, for example, two 19th-century weights from the Asante culture used to measure gold [37 and 38]. While artisans have given this genre a repertoire of animal and figural forms that illustrate various fables and proverbs, the more geometric character of these two examples is typical and relates to the symbols used as stamped decorations on the adinkra cloth also created among the Asante.[12] Likewise, *Composition Concrete (Study for Mural),* created in the late 1950s by Stuart Davis [96], features a rich variety of numbers and abstract shapes. Existing somewhere between gesture and shape, these forms interlock like pieces of a puzzle that, like the elements in "concrete music," are "selected, combined, and energized by a dynamic color scheme of vibrant red and blue, black and white." Davis demurred from providing any meanings for his idiosyncratic shapes, instead encouraging viewers to focus on the enjoyment of "the color-space relationships which give the painting its vigorous tone and structural feeling."[13]

Davis's painting was executed during the heyday of Abstract Expressionism, which had emerged from

explorations with the Surrealist concept of the indeterminate nature of human perception and experience as expressed in dream imagery and artistic techniques such as the creation of hybrid images (the "cadaver exquis"[14]), and the spontaneous, uncontrolled application of paint to a canvas by throwing and dripping. The final chapter of this book, "Lines, Waves, and Fractals," demonstrates that a certain order and pattern can be detected even in such seeming chaos. Several of the artists associated with Abstract Expressionism did use more contained shapes. A combination of ovals and vertical rectangles became the motifs for an extended series of paintings by Robert Motherwell, for example, *Elegy to the Spanish Republic No. LV* [94], painted in 1955–60. This recurring image has often been interpreted existentially as representing the anatomy of a bull—a reference to the enduring memory of the Spanish Civil War (1936–39) by artists of Motherwell's generation. The contrasts of form and color suggest metaphors for war and peace, life and death, freedom and oppression.

Robert Motherwell, *Elegy to the Spanish Republic No. LV,* 1955–60 [94]

2

Sacred and Profane Geometry

[The] starting point of ancient geometric thought is . . . a meditation upon a metaphysical Unity, followed by an attempt to symbolize visually and to contemplate the pure, formal order which springs forth from this incomprehensible Oneness. It is the approach to the starting point of the geometric activity which radically separates what we may call the sacred from the mundane or secular geometries.

—Robert Lawlor, *Sacred Geometry*

Democratic Republic of the Congo, Kuba people, *Hat,* early 1900s [54]

The Egyptian *Book of the Dead of Hori* from Dynasty 21 [6] is a guide to the afterlife that records various spells and illustrates scenes from the under-world. The central element, the Book of Gates, is organized into two registers of rectangular com-partments; each is framed by a zigzag or looping design, and in each sits a fierce, animal-headed figure holding one or two knives.[1] The inscriptions on the papyrus contain the secret passwords that the deceased must present to each of the 16 gatekeepers who guard as many gates on the way to the afterlife. This object demonstrates how geometry functions as a means to mediate the physical and the metaphysi-cal realms and their impact on human existence.

The word "geometry" is derived from Greek words meaning "Earth measurement."[2] It has been

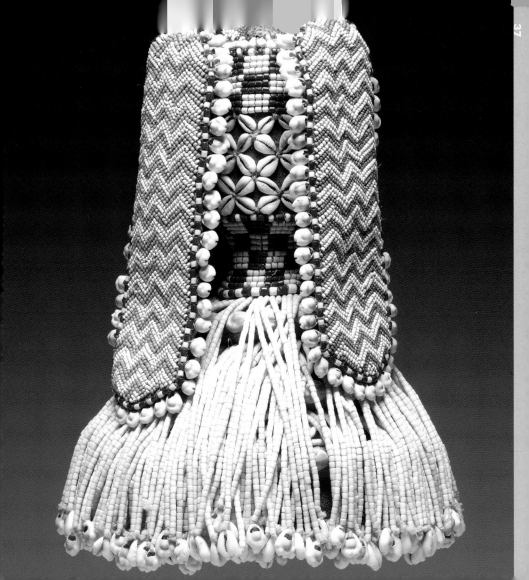

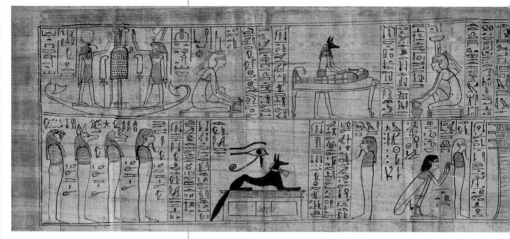

Egypt, Third Intermediate period, Dynasty 21, *Book of the Dead of Hori,* 1069–945 BC [6]

advanced that the origins of geometry lie in ancient Egypt, where systems were developed to recalibrate property lines each year after the annual flooding of the Nile that deposited the rich soil that supported the country's agricultural economy.[3] This fact is a potent expression of the cycles of nature and as Paul Calter notes: "If flooding of the Nile symbolized the annual return of watery chaos, then geometry, used to reestablish the boundaries, was perhaps seen as restoring law and order on earth."[4] This return to harmony in turn reinforced the idea of geometry being sacred because it represents order, indeed a divine order that, as described by Plato, "harmoniously" arranged the cosmos "according to . . . preexisting, eternal, paradigma, archetypes or ideas."[5] Ozenfant also affirms this idea that geometry can provide a sense of "order" and "method," as well as a "discipline" that we can imagine controls the world and by which we can achieve "a

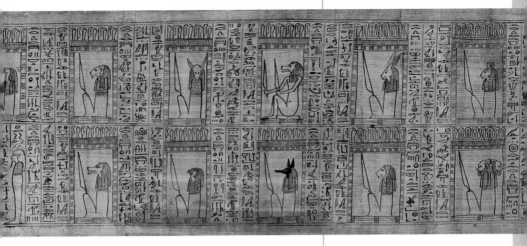

sanctioned unity."[6] This unity is the basis of the visual harmony that satisfies the "feeling, emotion, the mind" of the viewer, and when this "threefold need" is met it produces in us "a condition of euphoria."[7]

The notion of a system of harmonious proportions, "sanctioned unity," and "discipline" was inevitably subsumed into a symbolism of numbers that is a key element of our exploration of the metaphysical implications of geometry. Numbers are associated with individual shapes while at the same time predicating visual, formal, and conceptual relationships in art no matter how calculated or intuitive the approach of the artists. While there is certainly a range of symbolic numbers—5, 9, 12, etc., that represent units of time, choruses of heavenly beings, days of creation as noted in the book of Genesis, numbers of prophets, to name a few—we are focusing on the basic four numbers, which also signify a series of visual and experiential relationships

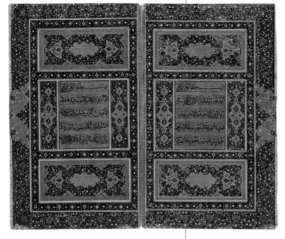

Iran, *Folio from a Koran*, 1500s
[23]

that link the mathematics of geometry to the rich traditions of symbolic numerology.

As Lawlor writes, "ONE . . . represents the principle of absolute unity, and as such has often been used as the symbol to represent God."[8] This number is often associated with the circle forming the halo or mandala that frames the deity in the visual traditions of many cultures. We have already examined circular motifs in Hindu and Buddhist traditions in the depictions of Shiva and Buddha and discussed how they indicate sacred or celestial realms. The circular mandala that surrounds the dancing Shiva frames the dance that signifies cycles of time. The flames on the mandala and in his upper left hand "symbolize destruction and the promise of re-creation." Sound is incorporated into the overall meaning of the image with the drum held in his upper right hand representing "creation or the beginning of time." And his raised foot "signifies the final release from the cycles of existence and promises salvation," as he "tramples the dwarf Mashalagan" in "an action symbolic of his victory over evil and ignorance."[9]

The conflict between Shiva and Mashalagan embodies the "principle of Duality"[10] or connection as represented by the line through which two points create a continuity. As seen in the doubling of the forms in the Koran folio from 16th-century Iran

[23] or in the casement window designed by Frank Lloyd Wright around 1904 [56], this duality can also encompass the principle of symmetry, or the mirroring of the other, which is a ready vehicle for expressing "harmony" and "order." The number three represents concepts as varied as the Trinity in Christianity and the essence of mother in India.[11] The 15th-century *Trinity* [21] by the French artist Laurent Girardin not only encompasses the principle of three entities embodying a single deity— here a decidedly human God the Father wearing the papal tiara, the crucified Christ, and the dove of the

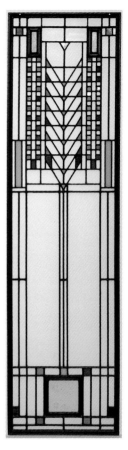

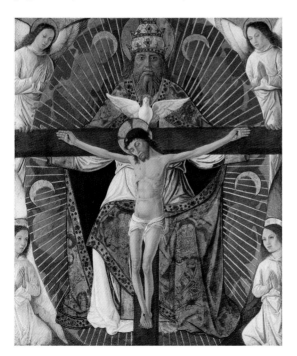

Laurent Girardin, *The Trinity*, c. 1460 [21]

Designed by Frank Lloyd Wright, *Casement Window*, c. 1904 [56]

Peter Carl
Fabergé, *Frame
with Nine
Miniatures*,
1896–1905 [51]

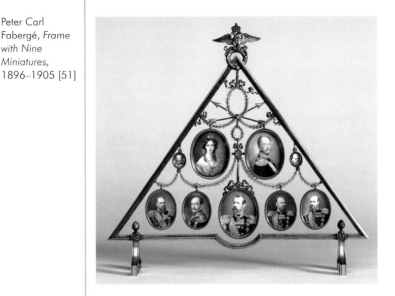

Holy Ghost—but also presents a composition de-
fined by the intersection of the cross with the oval
(circle) of a mandala or halo. On the profane level,
the triangular form of Peter Carl Fabergé's frame
for nine miniatures of 1896–1905 [51] bespeaks the
inherent symbolism of a form with an apex and two
subordinate angular endings. The arrangement of
the miniatures and their size could suggest a ranking
of the individuals, with the large male and female
portraits in the top row forming an inverted triangle
with the male subject in the middle of the next row:
a triangle within a triangle. The third point then
adds a "qualitative transition . . . the pure abstract
elements of point and line to the tangible, measur-
able state that is called a surface."[12]

The noted expert on African geometry Paulus Gerdes[13] conveys information provided by Kimbwandende Fu-Kiau, a scholar of Kongo culture, that V-angles and diamond shapes in the patterns of Kuba raffia cloth [52 and 53] also have "cosmological and didactic connotations."[14] The V-angle encompasses a sense of embrace as in "consciousness" as that of "giving," a "symbol of love and harmony... and of marriage and community."[15] These patterns serve as a means to convey the essential values of Kuba society to all its members. The impression of depth at the left and bottom edge of the cloth at the right [53] demonstrates how the "illusion of a cube" is created with hexagonal forms "by connecting every other vertex to the center, forming three diamonds, and shading each diamond differently."[16]

Democratic Republic of the Congo, Kuba people, *Embroidered Raffia Pile Cloth*, 1900s [52]

Democratic Republic of the Congo, Kuba people, *Embroidered Raffia Pile Cloth*, 1900s [53]

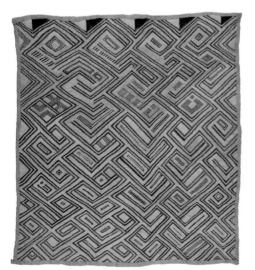

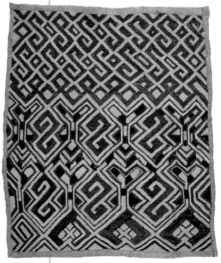

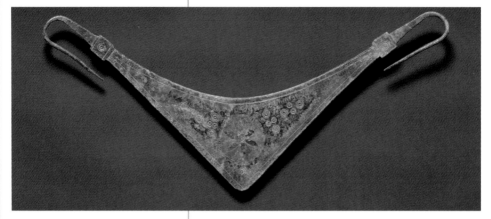

Greece, Geometric period, *Woman's Belt Hanger*, 725–675 BC [7]

This description is vividly illustrated in the ancient Greek woman's belt hanger [7] where the triangulation of three points—like the calculation of one's position in terms of height, depth, and width—results in a form perhaps meant to symbolize female reproductive anatomy. Yet the presence of this shape on an implement associated with women seems at odds with the gender nuances of the symbolism of numbers. Calter records that odd numbers are designated as masculine, with even numbers being female because they are considered "weaker."[17] Further, when odd and even numbers are added together they always result in an odd number, while two even numbers "can never produce an odd, while two odds produce an even." Finally, consider this specifically visual phenomenon: unlike odd numbers, when even numbers are presented there is no centralized element,[18] thus affirming the presumed hierarchical positioning of the male. Could these postulations then be applied to John Taylor

Arms's etching and aquatint *Gates of the City* of 1922 [62], where the two pointed arches anchored by three columns—a visual vocabulary inspired by Gothic cathedrals—may be read as a marriage of male and female?

The pointed arches in the Arms etching also appear in Albert Bouts's *Annunciation* [22], painted around 1480. Here the encounter between the Virgin Mary and the Archangel Gabriel takes place in a space defined by both rounded and pointed arches. The iconography is enhanced by the presence of the trefoil design in the arched window at the center of the composition, which undoubtedly refers to the

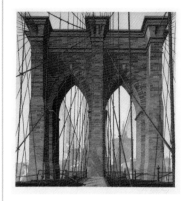

John Taylor Arms,
Gates of the City,
1922 [62]

Albert Bouts,
The Annunciation,
c. 1480 [22]

William Clift,
*Vaulted Ceiling,
Mont-Saint-
Michel, France,*
1982 [118]

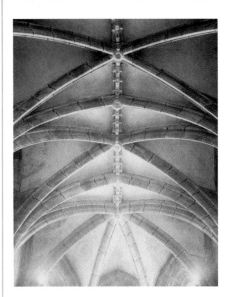

Trinity of Father, Son, and Holy Ghost—the unseen protagonists in the act of substantiation whereby the Son became man through the consent and willing participation of the Virgin Mary. The skeins of the vaults like the one at the right of the composition are the subject of William Clift's 1982 photograph *Vaulted Ceiling, Mont-Saint-Michel, France* [118]. The distinct pattern of the ceiling of this Benedictine abbey reveals the potential for an endless geometric progression of forms. Robert Mangold's 1995 *Curved Plane/Figure VII (Study)* [139] could also have a celestial source. One of the key figures in geometric art of the mid 20th century, Mangold is interested in a "sectionalized kind of painting that could be fragmented into parts and still exist as a whole."[19] Here a half-circle is divided vertically into

three sections—red, maroon, and gray; independent of the boundaries of the color sections are two ellipses inscribed from top to bottom edge.

In addition to uniting the entity of the one with the Trinity, Girardin's painting of the subject can be analyzed through the division of the composition into four quadrants by the crucifix. Each section is presided over by a cherubim partially obscured by the translucent red mandala, and a white-clad seraphim also appears at each corner. The number four encompasses various sets of elements that symbolize societal relationships or stages of life. Calter identifies the four elements of fire, air, water, and earth; the four seasons; the four directions of the compass; the four ages of a person; and the four societies of man: individual, village, city, and nation.[20] Further, the requirements for a university degree in the

Robert Mangold,
*Curved Plane/
Figure VII (Study)*,
1995 [139]

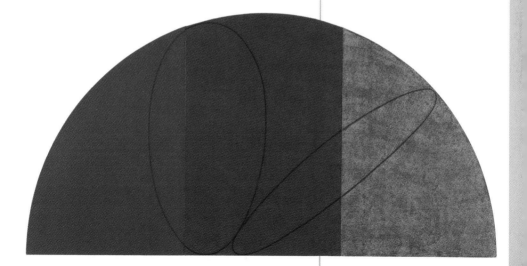

48

Peru, Chimú people, *Loincloth*, 1200–1460s [19]

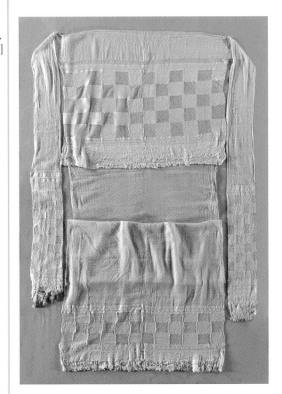

Middle Ages entailed proficiency in four disciplines: arithmetic, music, geometry, and astronomy.[21]

Four, as the "product of the procreative process, that is of multiplication," is the "square, and represents materialization."[22] This concept is prosaically illustrated in the technique of weaving in which the vertical warp intersects with the horizontal weft to create a squared design as seen in the Peruvian loincloth from the Chimú people of the 13th to 15th centuries [19]. The weaver emphasized these

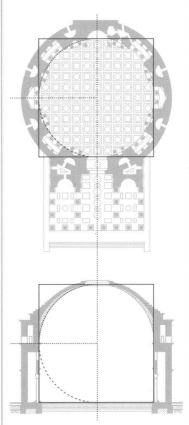

quadrants by highlighting a checkerboard design on the front and back panels, and on the waist ties.[23] As Calter notes, the square, "with its four corners like the corners of a house, represents earthly things, while the circle, perfect, endless, infinite, has often been taken to represent the divine or godly." Therefore, the "squaring of the circle," as in the plan of the Pantheon, becomes "a universal symbol of bringing the earthly and mundane into a proper relationship with the divine."[24] Originally built as a temple to the Roman gods, the Pantheon has served as a Catholic church since the 7th century.[25] The domed ceiling is a familiar symbol of the celestial dome of heaven and the oculus represents the sun: it is the source of all the light in the interior as the sun is for the world. To complete the celestial imagery, the square coffers originally contained bronze star ornaments. The combination of the circle and square completes the symbolic schema (fig. 6).

From these four basic numbers comes the capacity to extend two-dimensional form into three, even four, dimensions (the fourth dimension is time) and create volume encapsulated in geometric forms such as tetrahedrons, octahedrons, cubes, icosahedrons, and dodecahedrons. Known as the Platonic solids, they also embody "another metaphor for the original and ever-continuing creative act of the materialization of Spirit and the creation of form."[26] They "symbolically re-enact our cosmic history, and perfectly represent the great movements whose meanings they convey."[27] In Albrecht Dürer's 1514 engraving *Melencolia I* [25], one of the four humors associated alternately with ill temper (bile) as well as creativity is surrounded by tools "associated with

Fig. 6. Floor plan and transverse section, Pantheon, Rome

geometry, the one of the seven liberal arts that underlies artistic creation—and the one through which Dürer hoped to approach perfection in his own work."[28] At the left front edge of the composition we can see an orb or sphere, and at left center, a polyhedron. In the distance the name of the figure is framed by a rainbow, associated with the circle, and the figure herself holds a compass used to make

Albrecht Dürer,
Melencolia I,
1514 [25]

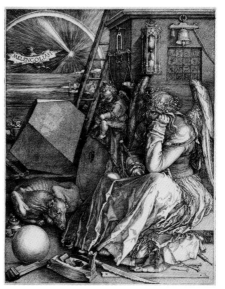

geometrical calculations, and at her feet we see a plane, a rasp, nails, and a ruler—tools for construction that reality that geometry makes possible.

The polyhedral forms in Sol LeWitt's *Working Drawings for "Continuous Forms"* [127] indicate the artist's sense of Platonic balance, also seen in the wall drawing itself (fig. 7), which was commis-

sioned by the Cleveland Museum of Art in 1987. The core of LeWitt's creative practice since the 1970s, such wall drawings are magnificent designs based on a variety of geometric motifs and concepts. The large shapes to the right of the doorway in the installation view (at the top left in the drawing) are contiguous trapezoidal planes that, with triangular shapes as well as schematics for tetrahedral

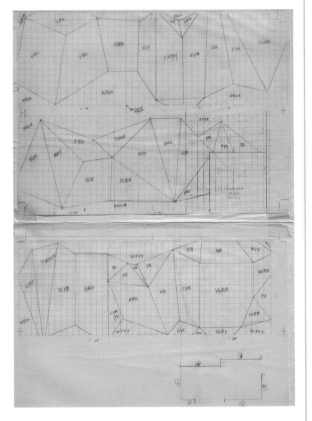

Sol LeWitt, Working Drawings for "Continuous Forms," 1987 [127]

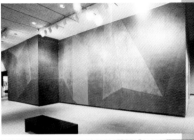

Fig. 7. Sol LeWitt, Continuous Forms, 1987

Syria, Damascus, late Mamluk period, *Bowl*, 1450–1500 [20]

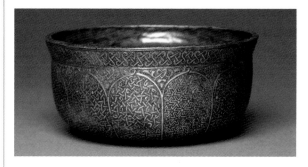

forms, unfold across the composition. LeWitt made notations about colors to be used for the different shapes in the working drawing. As Ozenfant notes, color is essential for the perception of form since "all substance is seen by the light it reflects, and all light is colour."[29]

The geometric character and decoration on everyday objects also enhances our experience and perception of the more banal aspects of our lives. The circular form of the 15th-century bowl from Syria forged in brass and decorated with silver and gold [20] is reminiscent of clay vessels fabricated in coils or on a potter's wheel. Many of these objects signal status and hierarchy through design and

New Zealand, Maori people, *Treasure Box*, 1800s [40]

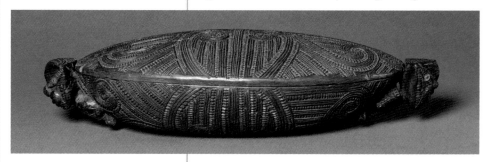

decoration, as in the example of the Maori treasure box [40]. This box features "low-relief spiral designs and small carved figures at each end," providing storage for various ornaments worn by chiefs. Because their special sacred character necessitated their being kept out of reach, such boxes were "hung from the rafters of the chief's house."[30] Hats from the Yombe and Kuba people of the Democratic Republic of the Congo are usually worn along with other symbols of a chief's position and authority such as "fly wisks, execution swords, and ivory scepters."[31] The Yombe hat [46] is an intricate tour de force of looped and knotted raffia fiber. The height indicates the wearer's rank, and the leopard claws at the crown "confirms the high status of its owner, for the leopard is considered to be the ruler of the animal realm."[32] The Kuba version festooned with cowrie shells and glass beads with three elaborate cloth flaps decorated with chevron designs [54]

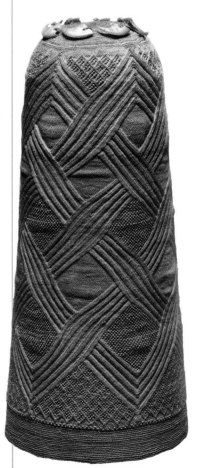

Democratic Republic of the Congo, Yombe people, *Chief's Cap*, late 1800s [46]

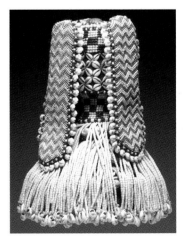

Democratic Republic of the Congo, Kuba people, *Hat*, early 1900s [54]

New Zealand,
Maori people,
*Fishing Canoe
Prow*, 1800s
[39]

Panama, Conte
style, *Hunchback*,
AD 400–900 [14]

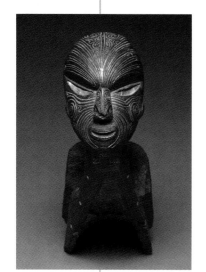

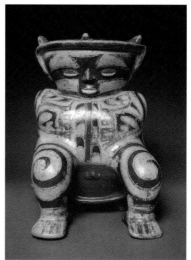

has a structure made of coiled raffia fiber; such
hats are worn by senior titleholders among the
Kuba people.[33]

One final consideration: decoration of the human
body—whether by tattooing, scarification, or body
paint—can indicate status, gender, and life situa-
tions that are often linked to sacred concepts. Tat-
tooing is a well-known tradition among cultures of
the Pacific, and the human head on the 19th-century
Maori fishing canoe prow is decorated with swirls
and spirals typical of traditional facial and body tat-
tooing [39].[34] "[S]wirling black, purple, and orange
patterns" cover the body of the earthenware figure
of a hunchback from Panama made before the Span-
ish arrived [14]. A snarling creature with antler-like
emanations on its head is painted on its sides.[35]

Decorative patterns also appear on the helmet mask [44] from the Bushoong, a group of the Kuba people. This mask is one of three—the others are a female face mask and a helmet mask not made of wood—that appear together in a dance re-enacting the mythical origins of the Kuba.[36] The vertical bars on the cheeks suggest scarification, the stippled holes in the forehead trace a hairline, and the knobs around the mouth, a beard. The features are a marvel of geometric simplicity: oval eyes with slits indicate pupils/sight, pyramid shape suggests nose, and triangulated ovals denote mouth and inner lips.

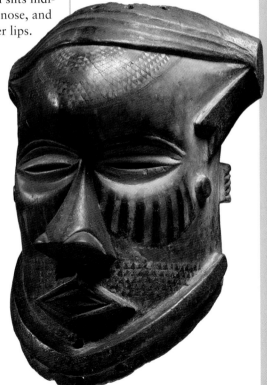

Democratic Republic of the Congo, Kuba people, *Helmet Mask,* mid to late 1800s [44]

3

Geometry and Modern Art

> [W]hen many ancient cultures chose to examine reality through the metaphors of geometry and music . . .
> they were already very close to the position of our most contemporary science.

—Robert Lawlor, *Sacred Geometry*

The precepts of modern art can be said to be based on the dictum of the modernist predecessor Paul Cézanne—"nature must be treated in terms of the cylinder, the sphere, the cone."[1] This statement was the basis for artists to examine the empirical world with an analytical eye, which eventually resulted in an abstraction of form that provided an enhanced experience of that form—whether as multiple views presented simultaneously or in actively interchangeable relationships between "figure" and "background." In Cézanne's 1895–1900 painting *The Brook* (fig. 8), the artist's "penetrating eye had discerned behind the bewilderingly multifarious surfaces of nature a delicate framework of rhythm and proportion, an architectural structure which lay like a crystal design behind the haphazard conformations of nature," as Werner Haftmann observed.[2]

Cézanne's dictum was a guiding principle behind the development of Cubism, as Pablo Picasso, Georges Braque (fig. 9), and their cohorts gave

Marsden Hartley,
Military (detail),
1914–15 [58]

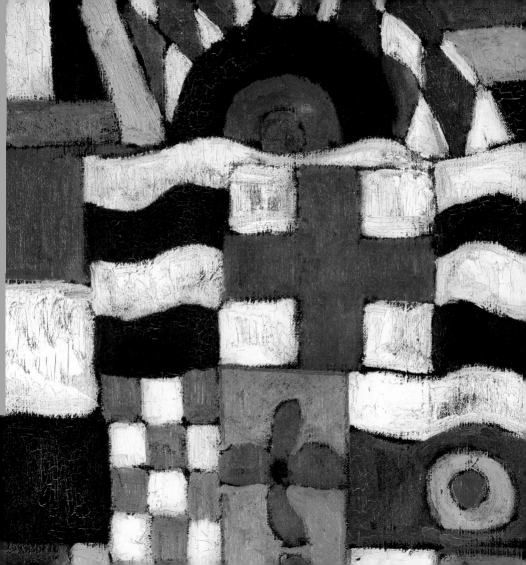

"ever great autonomy to the structure which had been extracted from nature by visual processes."[3] In prototypical Cubist compositions, figures, cityscapes, or still-life arrangements are presented as series of overlapping and intersecting planes that reflect the dimensionality of the object and the space around it in lieu of illusionistic techniques. In fact, it could be said that Cubism created another kind of illusion: presenting the dimensionality of an

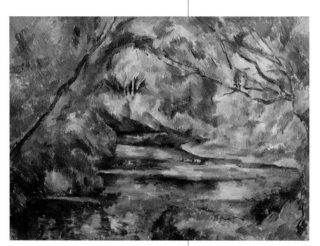

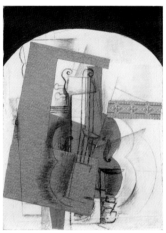

Fig. 8. Paul Cézanne, *The Brook*, 1895–1900

Fig. 9. Georges Braque, *The Violin*, 1914

object from all viewpoints at once rather than one view at a time. Futurist artists such as Gino Severini (fig. 10) used this approach to form to explore ideas of motion and dynamism.

The disparate planes of Cubism create a sense of pattern as captured in slow motion or sequential photography. Theodore Roszak captured a comparable composite view in his photogram of around

1932–39 [72]: a translucent entity at the center appears in multiple levels of space, anchored by the wire mesh and pieces of paper that suggest an open window at the left. The possibility of such views were revealed by the newly emergent automobile as well as by the photographic studies of Eadweard Muybridge in the 1880s [45]. The proliferation of faceted forms and the pointed dynamism in Edward Wadsworth's 1914–15 woodcut *Illustration*

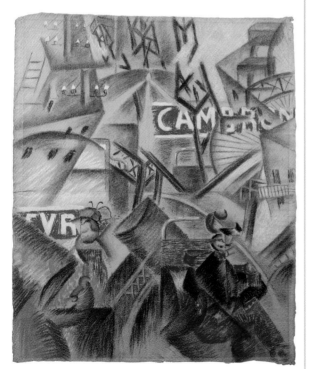

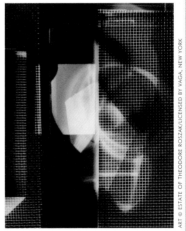

Fig. 10. Gino Severini, *Paris Subway, Ferris Wheel, and Eiffel Tower,* 1912–13

Theodore Roszak, *Untitled,* c. 1932–39 [72]

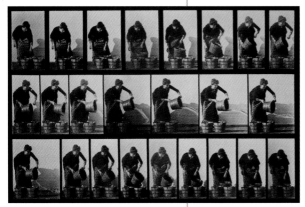

Eadweard Muybridge, *Emptying a Bucket of Water,* 1887 [45]

Edward Wadsworth, *Illustration (Typhoon),* 1914–15 [59]

Alvin Langdon Coburn, *Vortograph,* 1917 [60]

(Typhoon) [59] demonstrate aspects of the British vanguard movement Vorticism, which also celebrated the innovations of modern life. Members of the movement developed a "geometric style" that "merged the spatial analysis of cubism with the preoccupation with dynamic urban motifs and industrial landscapes."[4] A decade later the Russian-born American artist Louis Lozowick captured the urbanscape of New York with his evocative Cubo-Futurist rendering of the city's skyscrapers, bridges, and transportation system [65].

Parallel developments in painting and photography are obvious in a comparison of Lozowick's *New York* with Alvin Langdon Coburn's 1917 *Vortograph* [60], one of the first truly abstract photographs. Coburn achieved this image by reducing the subject to the "essential elements of light and form by placing a vortoscope, a triangular arrangement of mirrors, over the camera's lenses."[5] In the work of Sonia Delaunay, this dynamism was

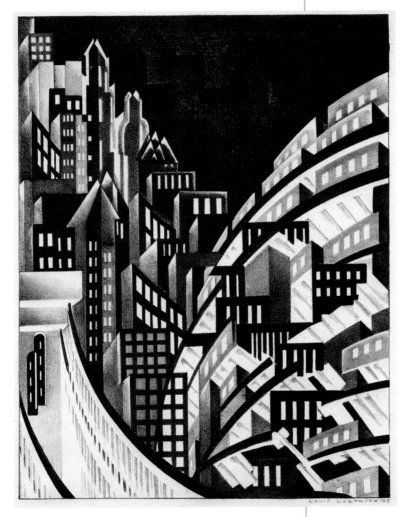

Louis Lozowick,
New York, 1923
[65]

combined with notions of "color harmonies" that "equated" different colors and hues with various pitches of music. Dubbed Orphism by the French poet and Cubist apologist Guillaume Apollinaire, this movement created by Sonia Delaunay and her husband, Robert, and Frantisek Kupka (fig. 11) introduced color into the Cubist palette. Their work was characterized by energetic, swirling, circular movements seen in her untitled lithograph from the 1960s–70s [99]. With Kurt Schwitters, the fractured vocabulary of Cubism was found in the bits, pieces,

Fig. 11.
Frantisek Kupka,
Amorpha, Fugue in Two Colors II,
1910–11

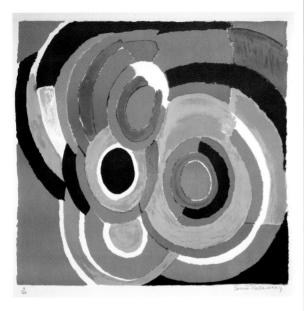

Sonia Delaunay,
Untitled, 1960s–
70s [99]

Kurt Schwitters,
Little Dance,
1920 [61]

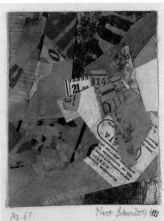

sections of newspaper, transit tickets, and packaging in his 1920 collage *Little Dance* [61]. This sensibility also reflected the antiart strategies of Dadaism, which Schwitters had been a part of in the previous decade.

The American artist Marsden Hartley used geometric forms to express a highly personal iconography in a style that was decidedly more painterly or gestural than his contemporaries. Just before the beginning of the First World War he found himself in Germany. That experience is the subject of his 1914–15 composition *Military* [58], one of several canvases and drawings in which he assembled "bright colors and geometric shapes [that] recall the ribbons, medallions, and banners of military

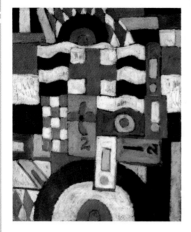

Marsden Hartley,
Military, 1914–15
[58]

pageantry"; some of the elements refer to a Prussian soldier, Karl von Freyburg, a friend of Hartley's who was killed in battle in 1914. The "red cross on a white background" is, of course, the international symbol of the Red Cross, and the "four-petaled red-and-black shape near the center of the canvas" alludes to von Freyburg's membership in the fourth regimental unit of the German Kaiser's guards.[6] The compression of the shapes of equal color value in the same picture plane is comparable to Léger's *Aviator* (see fig. 1), which the Hartley predates by five years.

These examples indicate the pervasiveness of modernist experimentation in art in Europe, Russia,

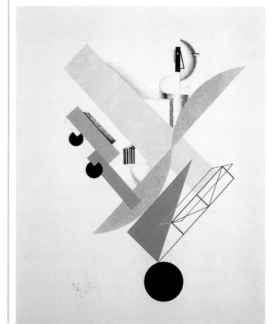

El Lissitzky,
*Plastic Figures
of the Electro-
Mechanical Show*,
1923 [66]

and later the United States and Latin America at the beginning of the 20th century as the ideas of modernism were quickly internationalized and merged with the specifics of national schools of modernism. In Russia, artists such as Kasimir Malevich and El Lissitzky developed an even more reductive vocabulary known as Suprematism or Russian Constructivism to symbolize the order and harmony of the new age. Malevich pursued this interest in paintings that manifest the minimum of color and elements based on geometry. Lissitzky's 1923 lithograph *Plastic Figures of the Electro-Mechanical Show; Victory over the Sun: Globetrotter in Time* [66] is an extreme abstraction of characters that would appear in a theatrical production. The ensemble of triangles, circles, and rectangles includes visual hints of airplane parts and automotive gears, wheels, and axles. The poignantly amusing drawing *Student (Costume Study for Goll's "Methusalem")* by the German Expressionist artist George Grosz [63], with its reductive geometric vocabulary based on triangles, rectangles, chevrons, and an oval, demonstrates his interest in Russian Constructivism and Dada; it also shares a "machine-like" sensibility with his Russian contemporaries.[7]

As part of this multinational moment, Piet Mondrian, working in the Netherlands, also moved from Cubism to a spare visual vocabulary comparable to Malevich's radically reductive visual stimuli, as seen in his *Composition with Red, Yellow, and Blue* of 1927 (fig. 12). Named "De Stijl" (The Style), this movement reflected the "sense of social and utopian destiny" that prevailed at the end of the First World War, "when the need for a

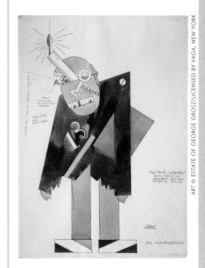

George Grosz,
Student, 1922
[63]

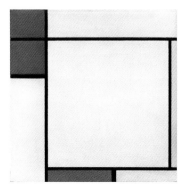

Fig. 12. Piet
Mondrian,
*Composition with
Red, Yellow, and
Blue,* 1927

Burgoyne Diller,
First Theme, 1963
[102]

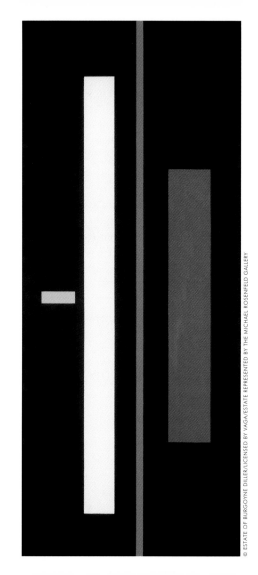

new order was sharply felt." The goal of De Stijl was to find a visual language that corresponded to contemporary ideals of a utopian society. This language came to include simple geometric forms—squares, rectangles—presented in primary colors, with an emphasis on a grid.[8] The work of these European artists had a profound influence on artists in the Americas; Mondrian's, in particular, was advanced in the United States by such artists as Burgoyne Diller [102], Fritz Glarner [86] (p. 33), and Charmion von Wiegand [88]. During the period between the two world wars, abstraction gained ground in the United States even in the context of realist tendencies that found acceptance more readily.

As John Lane has pointed out, abstract artists could be characterized as those who "based their art on observation of the natural world," that is "abstraction from nature," and those who "maintained that true abstract art could not be referential but must be the exclusive product of invented forms," that is "nonobjective" art and geometric abstraction.[9] The former tendency is obvious in Manierre Dawson's *Differential Complex* of 1910 [57], which demonstrates not only his familiarity with mathematics and engineering but also his exposure to the ideas of Arthur Wesley Dow, who emphasized the use of color and line in art as inspired by forms in nature.[10] What distinguished geometric abstraction in the United States was its focus on the material aspects of art making rather than the spiritual and philosophical underpinnings that predicated the work of their European coun-

Charmion von Wiegand, *Power Plant II*, 1949 [88]

Manierre Dawson, *Differential Complex*, 1910 [57]

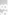

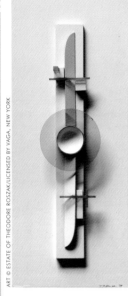

Theodore Roszak,
*First Study for
Vertical
Construction*,
1939 [77]

terparts. The Americans insisted on the inherent "realism" of their work, based on what Lane describes as "the modernist aesthetic principle that each art form should seek to reduce itself to its essential ingredients . . . line, color, light and shade, form, and space . . . without needing to justify its existence by making imitative references to subjects in the natural world."[11] Therefore the more art focused on its more elemental aspects, the more it was perceived as being true to reality, as opposed to figural tendencies that—whether in painting or sculpture—are inherently illusionistic and interpretive.

Roszak's *First Study for Vertical Construction* of 1939 [77] predicts how the use of materials would come into this definition of "the real" in abstract art in general and geometric art in particular in the 1960s. This work features the use of the then newly developed material, plastic, to create transparent planes that opened up comprehension of the form. He found predecessors and fellow travelers in this effort in artists associated with Russian Constructivism such as Nicholas Pevsner and Naum Gabo. Roszak's 1945 *White and Steel Polars* [80] is constructed of wood, steel, iron, and Plexiglas; its pristine, streamlined forms reflect a fascination with aviation that "he shared with many other artists of the thirties, including José de Rivera, Arshile Gorky, and J. Wallace Kelly." *White and Steel Polars* reflects Roszak's interest in science fiction and the "illustrations and descriptions of interplanetary vessels and space stations."[12] He also worked with Norman Bel Geddes on the Futurama diorama sponsored by General Motors at the 1939 World's Fair.[13]

Theodore Roszak,
*White and Steel
Polars,* 1945 [80]

Georgia O'Keeffe, *Morning Glory with Black*, 1926 [68]

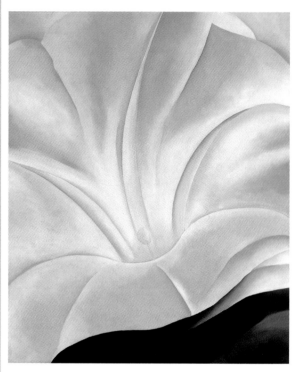

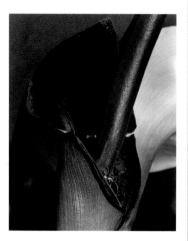

Imogen Cunningham, *Black and White Lilies III*, c. 1928 [70]

The Purist and Constructivist interest in industrial design and machine aesthetics was translated into a uniquely American interpretation in the Precisionist movement, many of whose artists were associated with the circle of photographer and modernist advocate Alfred Stieglitz and his wife, the painter Georgia O'Keeffe. The extreme close-up and focus on structure in O'Keeffe's 1926 *Morning Glory with Black* [68] and Imogen Cunningham's *Black and White Lilies III* [70], taken two years later, offer examples of sleek imagery that transforms the soft and

fragrant forms of flowers into surrogates for machine imagery. Even Stieglitz, noted for his more idealized views of urban and rural America, seems to have caught the new "streamlined" aesthetic in his 1933 image *Georgia O'Keeffe's Hand and Wheel* [74], a seductive meditation on the matched curves of the chrome rim of the hub cap and the white rubber wheel of the spare tire at the back of a car.

Similarly, Paul Strand's 1923 *Lathe, Akeley Shop, New York* [67] exemplifies the American infatuation with industrial imagery, which combined with a "streamlined" sensibility came to be encompassed in the transatlantic movement known as art moderne.

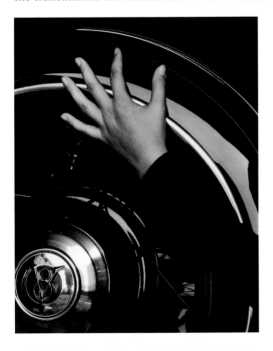

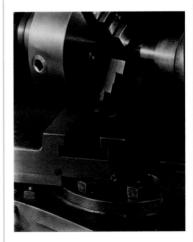

Alfred Stieglitz, *Georgia O'Keeffe's Hand and Wheel*, 1933 [74]

Paul Strand, *Lathe, Akeley Shop, New York*, 1923 [67]

This aesthetic informs the pristine sensibility of Grant Wood's *January*, 1940 [79]. Although he is usually associated with trends in American Regionalism between the two world wars, here Wood's regular rows of snow-covered corn stalks made into pyramids resemble eerie hooded presences appearing in the rhythm of a geometric pattern. It is ironic that this approach to form was put to the service of both utopian ideals and—in the case of Wood—the celebration of "hearth and home" that was central to nationalistic ideologies in countries with political tendencies as divergent as the United States and Germany in the 1920s and 1930s.[14]

American geometric abstractionists approached the more philosophical bent of their European con-

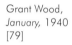

Grant Wood,
January, 1940
[79]

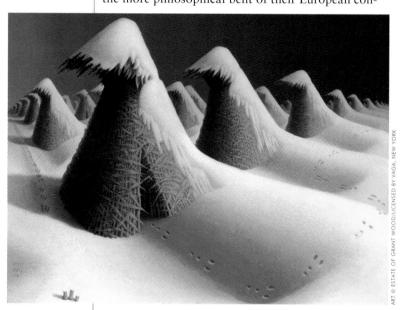

temporaries in their response to the demand in the 1920s and 1930s that art have social utility. Jack Lane reports that Stuart Davis, for example, "described the role of the modernist artist . . . in terms similar to that of a researcher seeking the conquest of nature through science," which would inevitably provide "a contribution to the knowledge of materialistic reality."[15] In 1937 Léger wrote in the periodical *Art Front* that workers would come to understand the "new art" if they had the "leisure time and access" to that art "since modernist art reflected their times and the products they manufactured."[16] Burgoyne Diller made a similar argument when, as director of the New York area easel section of the Works Progress Administration (WPA), he had to defend abstract art. Diller rationalized that the abstract murals commissioned for the Williamsburg Housing complex, for example, would provide forms that would be "aesthetically pleasing" and "more appealing" to the working-class residents "after a hard day's work," than "images of factories, city streets, and allegories of class struggle."[17] Davis himself found a middle ground between abstraction and realism in his own mural for the housing complex. He used forms abstracted directly from reality and skillfully manipulated color shapes, which can be seen in works such as *Composition Concrete (Study for Mural)* [96] (p. 34) commissioned for the H. J. Heinz Research Center in Pittsburgh.

A new geometric impulse appeared in art during the 1960s and 1970s under the rubrics of "geometric abstraction," "minimalism," and "color field" painting. Minimalism in particular was, in Lynn

Zelevansky's opinion, "arguably the most original North American artistic development of the postwar period."[18] In both painting and sculpture artists focused on "whole" forms "that shunned the traditional balancing of one element against another,"[19] as seen in Donald Judd's 1989 untitled sculpture (fig. 13). Sculptors simplified the component parts of their work to the minimum and eliminated the ped-

Fig. 13. Donald Judd, *Untitled*, 1989

Sol LeWitt, *24C*, 1991 [131]

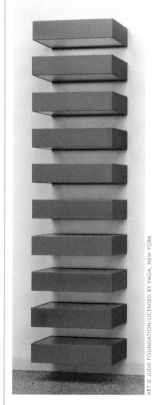

estal so that forms became an integral part of the environment.[20] Sol LeWitt's *24C* of 1991 [131], which is composed of identical individual open cubes painted the same color white to emphasize their totality and their anonymity, demonstrates this interest. This work also shows the related interest in "seriality," where works of art presented "systematic progressions or series based on mathematical sequences."[21] Joel Shapiro's 1989 untitled sculpture [129] (p. 116) indicates the commitment of Minimalist sculptors to present unadulterated industrial components in their work, as in Carl Andre's steel plates and Dan Flavin's fluorescent tubes. At the same time, there is an unexpected whimsy and dynamism to Shapiro's work, which defies gravity, balancing on one "leg" like a dancer kicking up its heels.

The genres of painting and sculpture merged as painters sought surfaces that embodied the forms formerly placed on the surface of a rectangle or square. Color and form purged of anecdotal detail constituted a new type of content, which as discussed above, emphasizes the work of art as "real" and "actual." The ideas of "beauty," "rationality," and "harmony" being reflected in the simple pristine forms were not lost on this generation of abstractionists. Yet the Americans continued, as they had in the 1930s and 1940s, to emphasize the basic elements of their work, such as color, form, and shape. In *Sea Painting I* of 1973–74 [110], Brice Marden reinforces this materiality by his use of wax with oil paint to increase the viscous presence of the surface of his paintings. Frank Stella evoked the

Brice Marden,
Sea Painting I,
1973–74 [110]

Frank Stella,
*Gray Scramble
(Single), VIII,*
1968 [108]

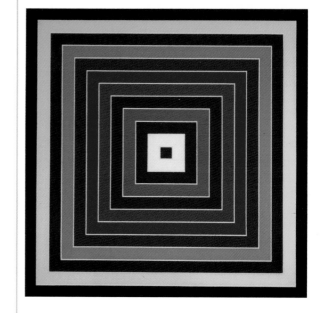

Josef Albers,
*Homage to the
Square: Star
Blue,* 1957 [95]

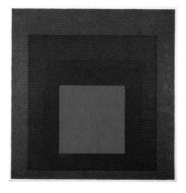

work of Josef Albers in his *Gray Scramble (Single),
VIII* of 1968 [108], with its telescoping arrange-
ment of squares of black, shades of gray, yellow,
orange, red, green, and blue. Albers's composition
Homage to the Square: Star Blue of 1957 [95]
emerged from his extended research and experimen-
tation with color relationships. The basis of this
work, according to Miklós Peternák, is "interfer-
ence patterns or random numbers,"[22] which would
describe the phenomenon of fractals as science
reveals the consistency of that interference and that
randomness. By the 1980s Stella had begun to
explore the potential of the shaped canvases he had

Fig. 14. Frank
Stella, *Giufa e la
Statua de Gesso*,
1985

developed in the 1960s, creating lively wall pieces
that bridged the divide between painting and sculp-
ture. *Giufa e la Statua de Gesso* (fig. 14) of 1985 is
an illusionistic tour de force consisting of patterned
cylinders, cones, and planes.

Perhaps no other work in this group is as iconic
an image of contemporary geometric art as Al Held's
Jupiter IV of 1974 [112]. This spare but deceptively

Al Held, *Jupiter IV*,
1974 [112]

complex composition reflects developments in his work in the late 1960s, when, according to Michael Auping, Held "restricted his palette to black and white in order to emphasize complex structural and spatial relationships."[23] Arcs bump into squares and rectangles; sporadic prismatic forms reveal themselves gradually; the perspective shifts as we focus on the orthogonal lines describing the three-dimensional forms; notions of transparency and solidity come to the fore as the extraordinarily bold lines suggest a box that is undercut and obscured by what seem to be simple lines defining other forms. The physicality of lines and the workings of illusionism on the two-dimensional surface are brought into high relief.

Zelevansky notes a greater degree of globalization during this period and "the coalescence of an intercontinental art world"[24] as indicated by the work of the French artist Victor Vasarely, the American artist Sean Scully, and the British artist Bridget Riley. Vasarely and Riley, along with American Richard Anuszkiewicz, represent the phenomenon known as Op Art (optical art). Riley's *Elapse* [119], commissioned by the Print Club of Cleveland in 1982, features her signature linear waves whose visual impact is predicated on the interest in sensory effects—produced here by the varied but regular distances between the successive curved lines. Anuszkiewicz achieves dizzying effects in his *Prisma* of 1968 [107], creating what he has described as "multiple squares, vertical bands, and bands around a center"[25] painted in fully saturated hues to create dazzling optical effects in which the complementary

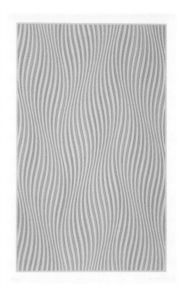

Bridget Riley,
Elapse, 1982
[119]

colors vibrate off one another. Anuszkiewicz studied with Albers, and, as Auping noted, although associated with the Op Art tendencies in mid-century American art, Anuszkiewicz was more involved in the "visual function of color" than in "optical illusion."[26]

Vasarely's *Lom-Lan* [85], painted 1949–52, is slightly earlier than his more familiar optical illusions, also produced through repetitive patterns of diagonal lines, but the exploration of the visual effect achieved through the juxtaposition of

Richard
Anuszkiewicz,
Prisma, 1968
[107]

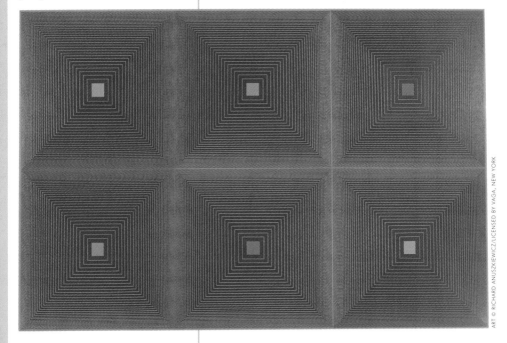

recurring color areas of yellow, orange, gray, and black against a brown background relates as well to the work of Albers. The effect is an array of fluctuating planes as if a building schema had gone mad. In a more discrete manner, Scully deviates from his usual adherence to horizontal and vertical patterns to introduce the diagonal in his 1991 woodcut *Planes of Light* [133]. According to the artist, this simple gesture adds "expressive significance" to his work.[27]

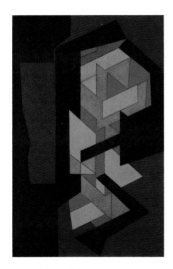

Victor Vasarely,
Lom-Lan, 1949–
52 [85]

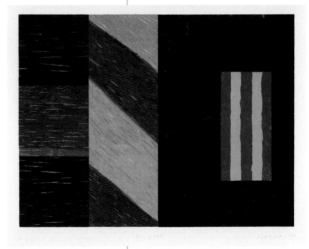

Sean Scully,
Planes of Light,
1991 [133]

4 Lines, Waves, and Fractals

[E]very form and color is linked with a specific emotion [and creates] a language that is felt (not symbolical), and which is that of all great universal and permanent art.

—Amédée Ozenfant, *Foundations of Modern Art*

The evolving universe around and within ourselves can be encountered only through the sensory instrument that we inhabit. Therefore our brains and bodies necessarily shape all our perceptions, and have themselves been shaped by the same seen and unseen energies that have shaped every perceivable thing.

—Robert Lawlor, *Sacred Geometry*

We have so far considered geometry as the phenomena of flat surfaces (plane geometry) and rigid three-dimensional objects (solid geometry). We have also considered the symbolism of geometry, on both sacred and profane planes, and investigated how geometry relates to symbolic numbers. And we have digressed to consider the phenomenon of geometry and modern art. This section examines how even the most abstract thoughts and images might be represented and developed in geometric terms, and considers the phenomena of lines, waves, patterns, and fractals.

Hiroshi Sugimoto, *Hall of Thirty-Three Bays* (detail), 1995 [140]

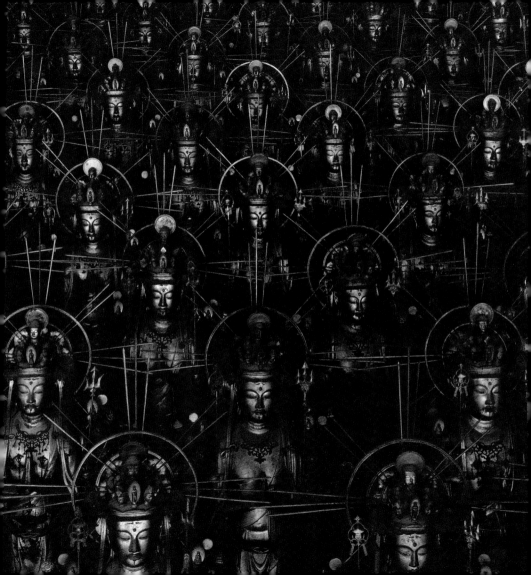

Jean-Baptiste II Tilliard, *Armchair*, c. 1765 [31]

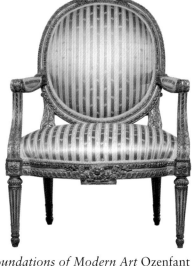

Hiroshi Seto, *Square Vase*, 1984 [124]

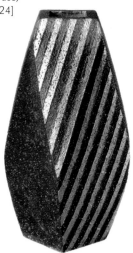

In *Foundations of Modern Art* Ozenfant positions the line as a "constant" of the "sensation and elements of form in nature and in art,"[1] since through their vertical, horizontal, oblique, or curvilinear qualities lines communicate sensations that match their character (for example, the curves of hills can represent the forms of a woman's body).[2] Or we can consider the welcoming perspective of the linear design on the upholstered back and seat of an 18th-century chair made by Jean-Baptise II Tilliard [31] or the diagonal pattern in a 20th-century vase by the Japanese potter Hiroshi Seto [124], which enhances our visual experience of the angular, polyhedral form of the container. Some of the earliest objects in this exhibition show such curvilinear, circular, or spiral forms, including two objects from approximately the same period but produced in cultures thousands of

miles apart: the squat jar with lug handles from the Predynastic period in Egypt (4000–3000 BC) [1] and the Neolithic-period ceramic jar from Gansu province in China (3000–2500 BC) [2]. The spirals on the former are discrete entities connected to one another by thin undulating bars painted on the diagonal. Such spiral and wavy lines are believed to "mimic the kind of mottled surface and veining that is characteristic of hard stone"[3] out of which the earlier prototypes of this pottery vessel would have been fabricated. On the second jar, the spirals are continuous swirls that literally engulf the belly of the pot.

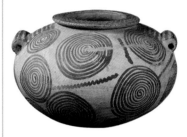

Egypt, Predynastic period, *Squat Jar with Lug Handles*, 4000–3000 BC [1]

China, Gansu province, Neolithic period, *Jar*, 3000–2500 BC [2]

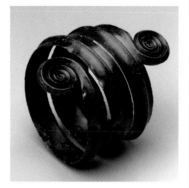

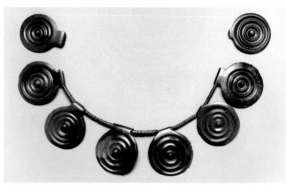

Hungary, Bronze Age, *Turned Armilla*, c. 1500 BC [4]

Hungary (possibly), *Necklace Elements*, 1400–1300 BC [5]

Fifteen centuries later the spiral is also the main motif of two armillas (arm bands) [4 and 3] (p. 13) and a series of elements for a necklace from central Europe [5]. These manmade spirals mimic one found in nature—that of the nautilus shell, the source for the logarithmic measures of progression that are the basis of the Fibonacci number sequence. The radius of each new chamber of a nautilus shell

Hiroshi Sugimoto, *Hall of Thirty-Three Bays*, 1995 [140]

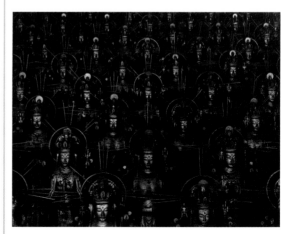

grows at a rate determined by a specific proportion to the previous one; Fibonacci numbers begin with 0 and 1 and increase by adding the two last numbers together (0, 1, 1, 2, 3, 5, 8, 13, 21, etc.). In a comparable way *Hall of Thirty-Three Bays*, Hiroshi Sugimoto's 1995 photograph of multiple Buddha heads connected by circular elements [140], conveys the potential for endless repetition, which may also be the subject of the decorative vessel by Helen Naha on which a series of spirals serve as finials in a pattern of triangles [134]. Not only does this vessel demonstrate the translation of this motif on the American continent, it also has surprising historical continuity with a 12th-century Anasazi jar from northern Arizona [18].

Helen Naha, *Vessel*, before 1993 [134]

North America, Southwest, Anasazi people, Tularosa Black-on-White style, *Jar*, c. 1100–1250 [18]

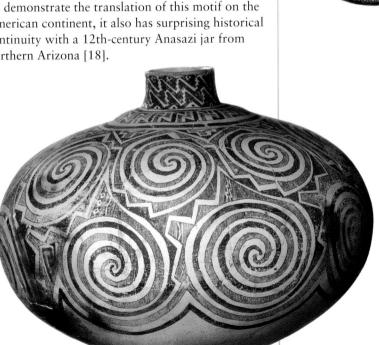

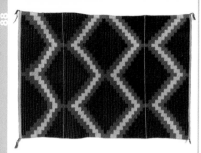

North America, Southwest, Navajo people, *Hubbell Revival Rug*, c. 1890–1910 [49]

In the Navajo Hubbell Revival rug woven around 1890–1910 [19], the dynamic character of zigzag lines allowed the weavers to "convey a level of energy and agitation"[4] not seen in simple banded compositions. Here successive lines intersect with those in adjacent rows, creating diamond motifs. Originally designed as a "fancy" element in this genre of weaving, after the 1880s the diamond became a dominant motif in Navajo blankets.[5] A comparable effect can be observed in a 16th–17th century Italian needlepoint and bobbin lace table-cloth [24], where a zigzag pattern is combined with doubled-armed crosses. The antelope headdress [55] from the Bamana people in Mali, a highly abstracted schema of the human body, also uses the

Italy, *Lace Table Cover*, 1500–1700 [24]

zigzag motif. The curve of the legs and the triangular shape behind them give the impression that the figure is about to be shot from a bow like an arrow. This jagged motif signals thunderbolts of energy on Ettore Sottsass's *Fruit Bowl* of 1982 [120]. These works demonstrate the potential of line to convey specific emotions and motion or stasis, and to imitate lines seen in the contours of the environment around us.

We have seen how waves of lines create optical experiences in the work of geometric artists of the 1960s and 1970s. A similar effect can be observed in Nancy Youngblood Lugo's *Carved Vessel* of 1994 [138] and the 1978 warp-faced rep weaving *Landform Red* by Lia Cook [116]. Despite the static

Mali, Bamana people, *Antelope Headdress*, 1900s [55]

Designed by Ettore Sottsass, *Fruit Bowl*, 1982 [120]

Lia Cook,
Landform Red,
1978 [116]

quality of the lines swirling up and down the body of Lugo's vessel, the vertical orientation of the pattern of lines approximates longitudinal waves. Cook draws on the model of transverse waves with a fold in the sequence. In his 1959 photograph *Grasses, Wisconsin* [98], Harry Callahan captures wave patterns in simple arcs that slope across the composition in response to the movement of the wind. Edward and Brett Weston similarly capture naturally occurring patterns as in the former's *Dunes, Oceano* of 1936 [76] and the latter's *Dunes and Mountains, White Sands* of 1945 [81]. Like the waves of water on a fan painted by Nakamuro Hochu in the late 1700s–early 1800s [33] (title

Nancy
Youngblood Lugo,
Carved Vessel,
1994 [138]

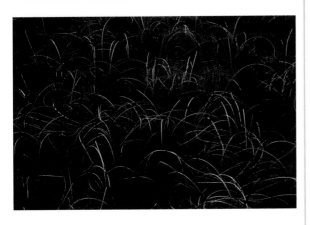

Harry Callahan,
*Grasses,
Wisconsin,* 1959
[98]

Edward Weston,
Dunes, Oceano,
1936 [76]

Brett Weston,
*Dunes and
Mountains,
White Sands,*
1945 [81]

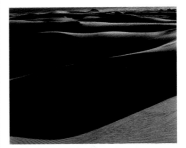

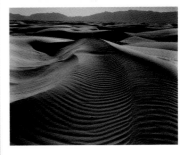

page), the shifting sands in these photographs are prime examples of waves that involve both longitudinal and transverse movements.

The consideration of waves in geometry encompasses the notion of pattern, the sense of periodic, consistent repetition of form or movement that results in a sense of organization. Pattern is perhaps the most observable aspect of geometry because forms and shapes proliferate and are organized into a coherent sequence in everything from the markings on mammals to the cycles of time, seasons, and the rhythms of life. As artist Al Smith has written:

[T]here is a rhythm to everything you do and a quality of motion in the moment of doing that flows beyond mere artisanship. . . . At varying octaves of being, each participates in individual and collective dances of cyclic activity . . . in multiple or polyrhythmic cycles of activity. . . . Collectively the rhythms create the "resultant composition" that [James] Lindesay describes. Further,

Fig. 15. Japan,
Edo period, *Dish*,
late 1600s

understand that within your cycles of activity, rhythms are constantly woven into and out of the fabric of your being.[6]

Such rhythms are most readily seen in decorative schemes for dishware (fig. 15) or the elements of construction as seen in the highly stylized pattern showing the structure of the trestle bridge in the 1833 color woodblock *Yahagi Bridge at Okazaki* by Ando Hiroshige [42]. That rhythms are "woven into and out of the fabric of your being" is readily seen in Chuck Close's portrait of the painter Paul Cadmus [141], which is made of hundreds of individual grid segments "filled with bright, multi-colored circles, loops, and dots," patterns influenced by Close's early exposure to Native American art.

In Paul III this grid is rotated 45 degrees, forming diamond shapes that are filled with bright, multi-colored circles, loops, and dots. Each diamond is an independent abstract painting, bursting with energy, gesture, and color. The overall effect is like a kaleidoscope, always changing as the viewer moves. Up close, the image is

Ando Hiroshige,
*Yahagi Bridge at
Okazaki*, 1833
[42]

Chuck Close,
Paul III, 1996
[141]

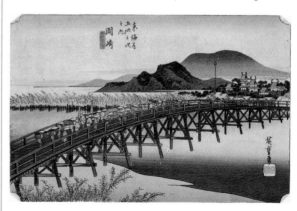

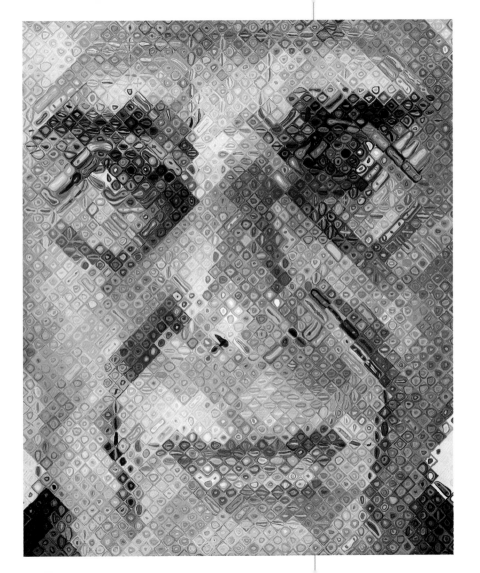

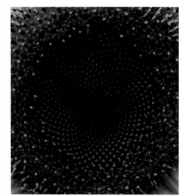

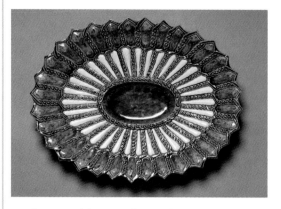

Paul Caponigro, *Sunflower Study,* c. 1960 [100]

Bernard Palissy and workshop, *Oval Dish,* late 1500s [26]

nearly impossible to read. At a distance, however, the individual elements crystallize into recognizable facial features.[7]

Patterns also predicated the aspect of modern geometric art known as the "serial image," the repetitive representation of the same element. Such patterning is seen in a study of a sunflower of around 1960 by Paul Caponigro [100], which finds parallels in the radiating design of Bernard Palissy's oval dish from the 16th century [26]. The Caponigro photograph illustrates how sunflowers grow through the successive additions of the stamen elements at its center. Martin Puryear's *Alien Huddle* of 1993–95 [136] reveals his "early interests in biology and nature." The emergence of two smaller spheres from the main form "suggests the growth and expansion of a dividing cell." Puryear is particularly aware that the wood he employs "has recently been alive," and that fact comes through in his handling of his material.[8] Mel Bochner's 1983 drawing *Quarry (Study)* [122] uses a dense interplay of lines

to create a crystalline structure. An important figure in conceptual and minimalist tendencies during the 1960s and 1970s, Bochner focused on the phenomenon of "serial order" as well as what he saw as the unpredictability of a geometrically determined growth of form.[9] This evidence of geometry on the cell level in determining the construction of the basic components of DNA, and the evidence that geometry constitutes the "architecture of bodily existence,"[10] allow us to understand the "geometric coding system" underlying all "life and consciousness" that, in turn, "gives us vital insight into the foundations of both spirit and matter, insights which can be applied in both spiritual and scientific pursuits."[11] Photography has enabled us to visualize phenomena beyond the measurable, for example, Arthur Siegel's *Photogram #9* of around 1946 [82]. As we are able to discern such marvels, we are then able to engage the metaphysical and the poetic.

Martin Puryear,
Alien Huddle,
1993–95 [136]

Mel Bochner,
Quarry (Study),
1983 [122]

Arthur Siegel,
Photogram #9,
c. 1946 [82]

United States,
Pennsylvania,
Coverlet, 1837
[43]

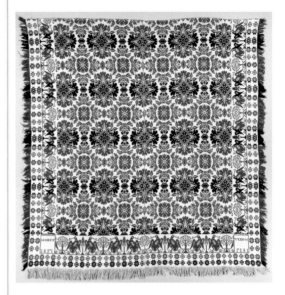

Ilse Bing, *Paris
Windows with
Flags, Bastille
Day*, 1933 [73]

An impulse to make patterns lies behind the woven diamond within circle motif on a 19th-century coverlet from Centre County, Pennsylvania [43]. Ilse Bing's 1933 photograph *Paris Windows with Flags, Bastille Day* [73] frames a wall of flag-festooned windows resembling the all-over design that is the organizing structure of the 1965 photograph *Composites: Philadelphia (Apertures)* by Ray Metzker [104]. Serial imagery was exploited to its fullest by Andy Warhol, who created almost endless permutations of repetitive photo silkscreen images on any number of canvases. Ellen Gallagher uses a similar technique in her 2003 *Bouffant Pride* [143] to introduce variety within seriality as she presents different heads of black people, each united in their

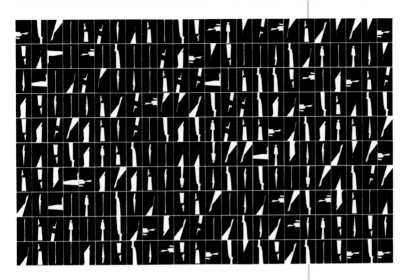

Ray K. Metzker,
*Composites:
Philadelphia
(Apertures),*
1965 [104]

Ellen Gallagher,
Bouffant Pride,
2003 [143]

obsession with blond hair, which is thickly laid on
in yellow paint.

Systems within patterns can be discerned that
create the rhythmic appearance of distinct elements.
Jasper Johns's 1977–78 *Usuyuki* [115] is organized
in three panels, each divided into "nine rectangular
sections, for a total of twenty-seven subsections."
In each subsection the artist then established a pat-
tern of hatch marks and imprints made by "circular
and rectangular cans." "While the same markings
appear throughout the composition, their position
in each panel is changed systematically to suggest a
clockwise movement from top to bottom, left to
right."[12] In a Qing dynasty scroll, a group portrait
Buddhist Monks of the Obaku Sect [28], a repeti-

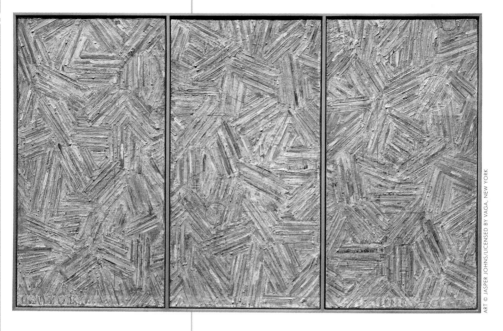

Jasper Johns, *Usuyuki*, 1977–78 [115]

tive pattern is similarly established by the figures' white robes, red shawls, and black necklaces. The resulting effect is waves of red curvilinear elements anchored by the relentless verticality of the black loops. As in the Johns, within this repetition variant elements such as mustaches or beards can be discerned; gestures likewise break the persistent uniformity while coincidentally offering a social as well as visual commentary.

These more intuitive expressions of geometry have been enhanced by the introduction of new concepts of space and time over the past two centuries. In Impressionism, artists considered optics and the

science of color. In Cubism, they considered time and space and the phenomenon of simultaneity; through photography they experienced the extra dimensions of time (the fourth) and space (the fifth). Richard Pousette-Dart, a contemporary of the Abstract Expressionists, presented the cosmic in his work, starting particularly in the 1960s. *Window of Unknowing* of 1975–76 [113] is a window into space whose geometric character is mediated by its permeable contours. He has described his images as "presences" that evoke as much states of mind as actualities of being. Pousette-Dart skirts the issue of chaos by suspending his particulate components in shimmering space, approximating a vision of matter described by Lawlor as being in a constant state of flux with atoms and molecules "being changed and replaced."[13]

While it would seem that the geometric impulse in American painting was eclipsed in the 1940s and

China, Qing dynasty, *The Buddhist Monks of the Obaku Sect,* 1600s [28]

Richard Pousette–Dart, *Window of Unknowing,* 1975–76 [113]

Fig. 16. Hans
Hofmann,
*Smaragd Red and
Permiating Yellow*,
1959

Jackson Pollock,
Number 5, 1950
[91]

1950s by a new interest in a formless expression of gestures and marks, Hans Hofmann combined gestural elements with strongly defined squares and/or rectangles that "appear to move forward or recede" or "push" and "pull," as seen in his *Smaragd Red and Permiating Yellow* of 1959 (fig. 16).[14] The geometry of fractals has also revealed that specific patterns can be discerned even within the seeming chaos of gestural abstraction. This has provided a new perspective on the work of Jackson Pollock, such as *Number 5* from 1950 [91], and verified his assertion that he could control the flow of paint in his drip process. Alison Abbott reported in *Nature*

magazine that physicist Richard Taylor analyzed Pollock's work and discovered fractal patterns.[15] "The geometric characterization of the simplest fractals is self-similarity: the shape is made of smaller copies of itself. The copies are similar to the whole: same shape but different size."[16]

The conceptual basis of this application to art was that the gesture recorded in lines, skeins, drips, swoops, and brushed episodes of paint results from the dynamics of human motion, as individuals "restore their balance" after each movement. Fractals then become "a fingerprint of the artist's body motion" and record the "angle and force behind the trajectory" of his motions.[17] In this context we can consider the geometry of the skeins of Sam Gilliam, who displays his own gestural technique in an untitled oil painting on Japanese paper of 1991 [130]. This work also reveals his penchant for cutting up and reassembling his stained and splattered surfaces, effectively reorienting, even disrupting, the

Sam Gilliam,
Untitled, 1991
[130]

Terry Winters,
*Application
Domains (11),*
1997 [142]

fractal patterning as seen in the rectangular shape applied onto the surface of his composition.

Earlier in this essay the concept of the line as the connection between two points was discussed. Several works in the exhibition feature linear patterns that begin to inscribe the paths of forms as well as the schema of their planar dimensions. Guillermo Kuitca's 1994 painting *Crown of Thorns (Songs on the Death of Children)* [137] (p. 127) features "spiky white linear forms . . . interwoven into a tangled all-over pattern" that pushes outward against the edges of the canvas. While the image and title conjure a specific Christian iconography, Kuitca himself "rejects easy religious or political interpretations, favoring more ambiguous readings."[18] It may not be far fetched, however, to relate the meandering quality of this image to his paintings that feature lights placed in the individual spaces of diagrams of rooms or apartments; these lights refer to the search for "Los Desaparecidos" (the missing youth alluded to in the title of Kuitca's work) who were seized and detained by the Argentine government during the 1970s.

Terry Winters's *Application Domains (11)*, a 1997 drawing [142], relates to the artist's longtime artistic strategy of engaging abstraction through organic, biomorphic forms. Indeed, within the snarl of lines that mimic the interlacing of warp and weft

in weaving are discernible eccentric aformal shapes similar to those found in the work of Winters's predecessors Joan Miró [78] and Alexander Calder [83]. Miró and Calder came from the tradition of free improvisation, the unconscious drawing essential to Surrealist practice. Winters adds the elements of the fourth and fifth dimensions to his work even though this drawing is enacted on a two-dimensional surface. These works bring us into the theoretical realm of "string theory," which examines the indeterminate nature of form and indicates the new frontiers for explaining the origins of the universe and the galaxies that comprise it.[19]

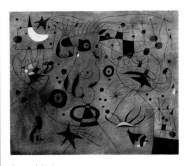

Joan Miró,
Woman with Blond Armpit Combing Her Hair by the Light of the Stars, 1940 [78]

Alexander Calder, *Two Systems*, c. 1946 [83]

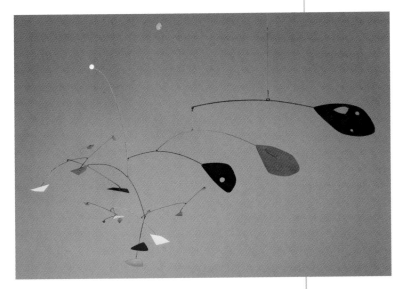

Conclusion | **Convergences**

> [T]he urge to abstraction stands at the beginning of every art and in the case of certain peoples remains the dominant tendency . . . this urge is best served through pure geometric abstraction . . . free of all external connections with the world.
>
> —Wilhelm Worringer, in Robert Lawlor, *Sacred Geometry*

The merger of geometry with cosmology, philosophy, and numerology that characterizes modern-day approaches to geometry is, Robert Lawlor writes, "part of a mystic doctrine of creation known as anthropocosmic."[1]

The first principle of this theory is that Man is not a mere constituent part of the universe, but rather he is both the final summarizing product of evolution and the original seed potential out of which the universe germinated.[2]

This bold statement was written in 1982. Since then world events in the economic, social, political, even cultural arenas have called into question this decidedly anthropocentric view of our place in the universe. What is more pertinent at this point in the history of human existence and creativity is the "convergence between the new biological science based on cybernetics and information theory and... Anthropocosm."[3] Such convergences work to equal-

Ray K. Metzker,
*Composites:
Philadelphia
(Apertures)*
(detail), 1965
[104]

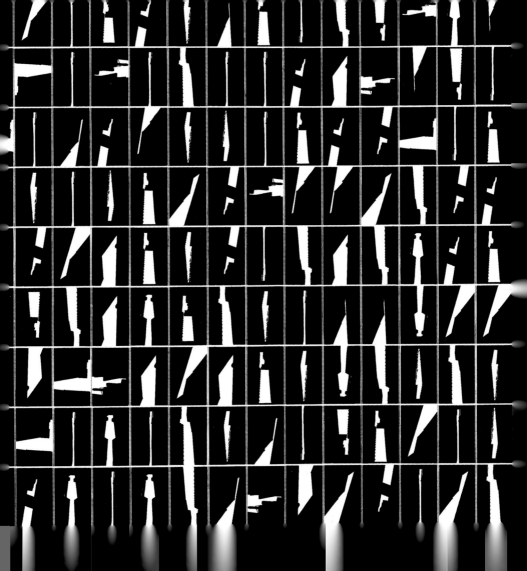

ize the relationships between the arts and sciences and correlate with the emergence of critical and theoretical models that reorient the conceptual relationship between the art of different cultures and the art of different genres as mentioned at the beginning of this essay. Two models relevant to this discussion are the "hybrid state,"[4] conceived by Papo Colo and Jeanette Ingberman at Exit Art Gallery in New York City, and "lateral thinking,"[5] the theory of the English educational philosopher Edward de Bono.

The Hybrid State—an interdisciplinary program of exhibitions, literature, film, and performances organized in 1991–92—examined the "ways that cultures influence each other and in the process transform each other" and asserts the "centrality of cultures considered peripheral" in world culture.[6] The comprehension of that centrality is to be achieved through the presentation of parallel histories that would unify "different opinions and attitudes and [place] work within the context in which it was produced."[7] In the context of the new world order, it investigates the history of the United States as a society of diverse cultures, as part of "a continent in the continuing process of changing people and cultures."[8] Lateral thinking provides an intellectual and conceptual framework in which to examine that process of change. Edward de Bono focuses on "alternative reasoning strategies . . . from vertical thinking [which] follows the most likely paths." This concept brings about repatterning and valorizes "curiosity, synergy and serendipity" as being "central to creativity" and privileges "the basic creative process over scientific reasoning."[9]

United States, Pennsylvania, *Coverlet* (detail), 1837 [43]

George Grosz,
Student (detail),
1922 [63]

These two models bring us back full circle to the initial premise for the organization of this exhibition. As a viewer, you are asked to rely on your own experiences to comprehend your relationship, emotive response, and intellectual response to the world of geometry manifest in the works of art presented here. The models provided by Ozenfant, Read and his associates, Colo and Ingberman, and de Bono allow us to approach world cultures of various epochs as comparable entities so that we will be able to appreciate and embrace the totality of human creativity on the most personal level. "The universality of Great Art," writes Ozenfant, "is possible, for all men have common factors, physical and moral."[10] This approach to art and form has been anathema to critical trends of the 1980s and 1990s, where diversity and a multicultural approach to art theory effected a deconstruction of the Eurocentric norm of art's ultimate criteria. But these thinkers do not fail to recognize the fact that cultures will inevitably change—especially as they come in contact with one another. Nor do they fail to recognize the importance of cultural specificity as we examine the appearance of these forms throughout world cultures and the history of mankind. Ozenfant perceptively noted that "the separation of the conventional element which clings to formal objects, that is to say, their symbolism" is by its nature "variable." The "direct emotion," which is "particular to form," is "constant."[11]

Kopf Maske / aufgeklappt
großer Reflektor mit
aufmontierten elektr. Lampe
als Licht hinan Salmische.

Notes

Introduction: 40,000 Years of Modern Art: An Approach and Methodology

1. [Amédée] Ozenfant, *Foundations of Modern Art,* trans. John Rodker (1931; reprint, New York: Dover Publications, 1952).

2. Read cofounded the institute with artist, historian, and poet Sir Roland Penrose.

3. *Forty-thousand Years of Modern Art: A Comparison of Primitive and Modern,* exh. cat., preface by Herbert Read, essay by W. G. Archer and Robert Melville (London: Institute of Contemporary Art, 1947).

4. "Purism," Guggenheim Museum website, 20 March 2006, http://www. guggenheimcollection. org/site/movement_ works_Purism_0.html.

5. *Forty-thousand Years of Modern Art,* 6.

6. Ibid.

7. Ibid.

8. Ibid.

9. Robert Lawlor, *Sacred Geometry: Philosophy and Practice* (London: Thames & Hudson, 1982), 4.

10. "Painting," Encyclopædia Britannica website, Encyclopædia Britannica Premium Service, 10 February 2006, http://www. britannica.com/eb/ article-60795.

11. Ibid.

12. See "Adinkra," University of Denver website, 12 April 2006, http://www. du.edu/duma/ africloth/adinkra.html.

13. "Painting," Encyclopædia Britannica website, 12 April 2006, http:// www.britannica.com/ eb/article-60790.

Shapes and Planes

1. The definitions in this and the following sentence are from the Merriam Webster website, 10 February 2006, http://www. merriamwebster.com/ dictionary/geometry.

2. "Sacred Geometry," Vesica website, 6 February 2006, http://vesica.org/ sacredgeometry- faq.html.

3. "Painting: Elements of Design" Encyclopædia Britannica website, Encyclopædia Britannica Premium Service, 10 February 2006, http://www. britannica.com/eb/ article-60795.

4. Michael Auping, *Abstraction Geometry Painting: Selected Geometric Abstract Painting in America Since 1945,* exh. cat. (New York/Buffalo: Harry N. Abrams/ Albright-Knox Art Gallery, 1989), 78.

5. Michael Cunningham et al., *Masterworks of Asian Art* (Cleveland/New York: Cleveland Museum of Art/Thames & Hudson, 1998), 146.

6. Paul Calter, "The Circle, the Wheel of Fortune, and the Rose Window," in *Squaring the Circle: Geometry in Art and Architecture,* Dartmouth College website, 10 February 2006, http://www.dartmouth.edu/~matc/math5.geometry/unit9/unit9.html.

7. Ibid.

8. "Crosses," Cumberland Inn Museum website, 20 March 2006, http://www.cumberlandinn.com/cross/types.htm.

9. Pamela McClusky, *Art from Africa: Long Steps Never Broke a Back,* exh. cat. (Seattle/Princeton: Seattle Art Museum/Princeton University Press, 2002), 109.

10. "Cross," Wikipedia, the Free Encyclopedia website, 20 March 2006, http://en.wikipedia.org/wiki/Cross.

11. Collections page portal, Cleveland Museum of Art website, 10 February 2006, http://www.clevelandart.org/explore/.

12. See K. Anthony Appiah, "The Arts of Africa," *New York Review of Books* 64 (24 April 1997): 46–51.

13. Collections page portal, Cleveland Museum of Art website, http://www.clevelandart.org/explore/.

14. The exquisite corpse drawing technique was invented by the Surrealists to create a single image from successive contributions by different artists. Each artist obscured his or her work before passing the drawing to the next artist; the outcome, being composed of disparate elements—human and nonhuman—was an image that could only have emerged from a dream or nightmare.

Sacred and Profane Geometry

1. Lawrence M. Berman, *Catalogue of Egyptian Art* (Cleveland: Cleveland Museum of Art, 1999), 370–72.

2. "Geometry," Encyclopædia Britannica website, Encyclopædia Britannica Premium Service, 20 March 2006, http://www.britannica.com/eb/articleId-126112.

3. Robert Lawlor, *Sacred Geometry: Philosophy and Practice* (London: Thames & Hudson, 1982), 6.

4. Paul Calter, "The Golden Ratio and Squaring the Circle in the Great Pyramid," in *Squaring the Circle: Geometry in Art and Architecture,* Dartmouth College website, 6 February 2006, http://www.dartmouth.edu/~matc/math5.geometry/unit2/unit2.html.

5. Matila Ghyka, *The Geometry of Art and Life* (New York: Dover, 1977), ix.

6. [Amédée] Ozenfant, *Foundations of Modern Art,* trans. John Rodker (1931; reprint, New York: Dover Publications, 1952), 245.

7. Ibid., 240.

8. Lawlor, *Sacred Geometry,* 12.

9. Collections page portal, Cleveland Museum of Art website, 10 February 2006, http://www.clevelandart.org/explore/.

10. Lawlor, *Sacred Geometry,* 12.

11. Ibid.

12. Ibid.

13. See Paulus Gerdes, *Geometry from Africa: Mathematical and Educational Explorations* (Washington, D.C.: Mathematical Association of America, 1999).

14. Paulus Gerdes, "Interweaving Art and Mathematics in African Design," *International Review of African American Art* 19, no. 3 ("Rhythm of Structure: MathArt in the African Diaspora") (2004): 45.

15. Ibid.

16. Calter, "Polygons, Tilings, and Sacred Geometry," in *Squaring the Circle,* 6 February 2006, http://www.dartmouth.edu/~matc/math5.geometry/unit5/unit5.html.

17. Calter, "Pythagoras and Music of the Spheres," in ibid., http://www.dartmouth.edu/~matc/math5.geometry/unit3/unit3.html.

18. Ibid.

19. Quoted in Michael Auping, *Abstraction Geometry Painting: Selected Geometric Abstract Painting in America Since 1945,* exh. cat. (New York/Buffalo: Harry N. Abrams/Albright-Knox Art Gallery, 1989), 172.

20. Calter, "Number Symbolism in the Middle Ages," in *Squaring the Circle,* http://www.dartmouth.edu/~matc/math5.geometry/unit8/unit8.html.

21. Ibid.

22. Lawlor, *Sacred Geometry,* 12.

23. Collections page portal, Cleveland Museum of Art, 20 March 2006, http://www.clevelandart.org/explore/.

24. Calter, "The Golden Ratio and Squaring the Circle in the Great Pyramid," in *Squaring the Circle,* http://www.dartmouth.edu/~matc/math5.geometry/unit2/unit2.html.

25. "Pantheon, Rome," Wikipedia, the Free Encyclopedia, 10 February 2006, http://en.wikipedia.org/wiki/Pantheon,_Rome.

26. Lawlor, *Sacred Geometry,* 96.

27. Ibid., 106.

28. "Melencolia," Metropolitan Museum of Art website, 10 February 2006, http://www.metmuseum.org/toah/hd/durr/hod_43.106.1.htm.

29. Ozenfant, *Foundations of Modern Art,* 252.

30. Collections page portal, Cleveland Museum of Art, 20 March 2006, http://www.clevelandart.org/explore/.

31. Ibid.

32. Ibid.

33. Ibid.

34. Ibid.

35. Ibid.

36. Ibid.

Geometry and Modern Art

1. Quoted in Werner Haftmann, *Painting in the Twentieth Century,* trans. Ralph Maneheim (New York/Washington: Frederick A. Praeger, 1965), 1: 32.

2. Ibid., 77.

3. Ibid.

4. Collections page portal, Cleveland Museum of Art website, http://www.clevelandart.org/explore/.

5. Ibid.

6. Ibid.

7. Diane De Grazia and Carter Foster, ed., *Master Drawings from the Cleveland Museum of Art* (Cleveland/New York: Cleveland Museum of Art/Rizzoli International Publications, 2000), 246.

8. See "De Stijl," Guggenheim Museum website, 12 April 2006, http://www.guggenheimcollection.org/site/movement_works_De_Stijl_O.html.

9. John Lane, "The Meanings of Abstraction," in John R. Lane and Susan C. Larsen, *Abstract Painting and Sculpture in America, 1927–1944,* exh. cat. (Pittsburgh/New York: Museum of Art, Carnegie Institute/ Harry N. Abrams, 1983), 11.

10. Collections page portal, Cleveland Museum of Art website, http://www. clevelandart.org/ explore/.

11. Lane, "Meanings of Abstraction," 10.

12. Both quotes from Joan Marter, "Theodore Roszak," in Lane and Larsen, *Abstract Painting and Sculpture in America,* 213.

13. Ibid.

14. See Wendy Kaplan, ed., *Designing Modernity: The Arts of Reform and Persuasion, 1885–1845,* exh. cat. (New York/Miami Beach: Thames & Hudson/Wolfsonian, 1995).

15. Lane, "Meanings of Abstraction," 12.

16. Ibid., 12–13.

17. Lowery Stokes Sims, "Stuart Davis in the 1930s: A Search for Social Relevance in Abstract Art," in Sims, *Stuart Davis: American Painter,* exh. cat. (New York: Metropolitan Museum of Art, 1991), 61.

18. Lynn Zelevansky, ed., *Beyond Geometry: Experiments in Form, 1940s–70s,* exh. cat. (Los Angeles/ Cambridge/London: Los Angeles County Museum of Art/MIT Press, 2004), 10.

19. Ibid., 76.

20. Ibid., 10.

21. Collections page portal, Cleveland Museum of Art website, http://www. clevelandart.org/ explore/.

22. Miklós Peternák, "Art, Research, Experiment: Scientific Methods and Systematic Concepts," in Zelevanksy, *Beyond Geometry,* 94.

23. Michael Auping, *Abstraction Geometry Painting: Selected Geometric Abstract Painting in America Since 1945,* exh. cat. (New York/Buffalo: Harry N. Abrams/ Albright-Knox Art Gallery, 1989), 65.

24. Zelevansky, *Beyond Geometry,* 10.

25. Auping, *Abstraction Geometry Painting,* 154.

26. Ibid., 67.

27. David Carrier, *Sean Scully* (London: Thames & Hudson, 2004), 132–33.

Lines, Waves, and Fractals

1. [Amédée] Ozenfant, *Foundations of Modern Art,* trans. John Rodker (1931; reprint, New York: Dover Publications, 1952), 259.

2. Ibid., 274.

3. Lawrence M. Berman, *Catalogue of Egyptian Art* (Cleveland: Cleveland Museum of Art, 1999), 107.

4. Mary Hunt Kahlenberg and Anthony Berlant, *The Navajo Blanket,* exh. cat. (New York: Praeger, 1972), 20.

5. Ibid., 19.

6. Al Smith, "Work Dance of a Rhythm Master," *International Review of African American Art* 19, no. 3 ("Rhythm of Structure: MathArt in the African Diaspora") (2004): 13.

7. Collections page portal, Cleveland Museum of Art website, 10 February 2006 http://www. clevelandart.org/ explore/.

8. Ibid.

9. Lynn Zelevansky, "Beyond Geometry: Objects, Systems, Concepts," in Zelevansky, ed., *Beyond Geometry: Experiments in Form, 1940s–70s,* exh. cat. (Los Angeles/Cambridge/London: Los Angeles County Museum of Art/MIT Press, 2004), 25–26.

10. Robert Lawlor, *Sacred Geometry: Philosophy and Practice* (London: Thames & Hudson, 1982), 4.

11. "Sacred Geometry," Vesica website, 7 April 2006, http://vesica.org/sacredgeometry-faq.html.

12. Collections page portal, Cleveland Museum of Art website, http://www.clevelandart.org/explore/.

13. Lawlor, *Sacred Geometry,* 4.

14. Collections page portal, Cleveland Museum of Art website, http://www.clevelandart.org/explore/.

15. Alison Abbott, "Fractals and Art: In the Hands of a Master," *Nature* 439 (9 February 2006), 648.

16. Michael Frame et al., "Introduction to Fractals," in *Fractal Geometry,* Yale University, 24 March 2006, http://classes.yale.edu.fractals.

17. Richard Taylor, quoted in Abbott, "Fractals and Art," 648.

18. Collections page portal, Cleveland Museum of Art website, http://www.clevelandart.org/explore/.

19. "String theory," Wikipedia, the Free Encyclopedia website, 24 March 2006, http://en.wikipedia.org/wiki/String_theory.

Conclusion: Convergences

1. Robert Lawlor, *Sacred Geometry: Philosophy and Practice* (London: Thames & Hudson, 1982), 90.

2. Ibid.

3. Ibid., 92.

4. *The Hybrid State,* ed. Papo Colo and Jeanette Ingberman, exh. cat. (New York: Exit Art, 1991).

5. Toby Kemp discussed de Bono's theory in his essay for *Lateral Thinking: Art of the 1990s,* exh. cat. (San Diego: Museum of Contemporary Art, 2002).

6. Colo and Ingberman, "Introduction," in *Hybrid State,* 58.

7. Ibid.

8. Ibid.

9. From Edward de Bono, *Lateral Thinking: Creativity Step by Step* (New York: Harper & Row, 1990), as referenced in Kemp, *Lateral Thinking,* 13.

10. [Amédée] Ozenfant, *Foundations of Modern Art,* trans. John Rodker (New York: Dover, 1952), 241.

11. Ibid.

Catalogue
of the
Exhibition

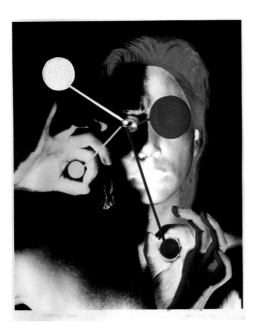

Ellen Carey,
Constructivist Portrait,
1983 [127]

1. Egypt, Predynastic period, Naqada IIb period. *Squat Jar with Lug Handles,* 4000–3000 BC. Ceramic; diam. 23.5 cm, h. 14.5 cm. Gift of the John Huntington Art and Polytechnic Trust 1920.1987

2. China, Gansu province, Neolithic period. *Jar,* 3000–2500 BC. Ceramic, slip; diam. 30.4 cm, h. 36.8 cm. Charles W. Harkness Endowment Fund 1930.332

3. Central Europe, Bronze Age. *Spiral Armilla,* c. 1500 BC. Bronze; 16.5 x 12.1 cm. Purchase from the J. H. Wade Fund 1988.4

4. Hungary, Bronze Age. *Turned Armilla,* c. 1500 BC. Bronze; 12.5 x 10.4 cm. Purchase from the J. H. Wade Fund 1988.5

5. Hungary (possibly). *Necklace Elements,* 1400–1300 BC. Bronze; diam 3.3–3.8 cm. Purchase from the J. H. Wade Fund 1992.68.a–c

6. Egypt, Third Intermediate period, Dynasty 21. *Book of the Dead of Hori,* 1069–945 BC. Papyrus; 22.9 x 158.2 cm. The Charles W. Harkness Endowment Fund 1921.1032

7. Greece, Geometric period. *Woman's Belt Hanger,* 725–675 BC. Bronze; w. 32.5 cm. The Jane B. Tripp Charitable Lead Annuity Trust 2006.5

8. Greece, Boeotian. *Fibula with Solar Design,* 700–675 BC. Bronze; 15.4 x 11.2 cm. John L. Severance Fund 1999.9

9. Italy, Italo-Geometric. *Bird Askos,* c. 700 BC. Ceramic; 33.5 x 42.3 x 15.5 cm. Purchase from the J. H. Wade Fund 1993.1

10. South America, Colombia, Central Highlands, Tolima people. *Figure Pendant,* AD 100–700. Hammered gold; 4.5 x 5.9 cm. Gift of Mrs. Theodate Johnson Severns 1980.209

11. Byzantium, North Syria. *Floor Mosaic Panel with Cross,* AD 300s–400s. Marble tessarae; 94.7 x 93.4 cm. Gift of Mr. and Mrs. J. J. Klejman 1968.270

12. Egypt, Byzantine period. *Roundel with Interlacing Knot from a Curtain,* AD 300s–400s. Plain weave ground, tapestry weave, supplementary weft wrapping; undyed linen, dyed wool; 45.2 x 57.7 cm. Gift of Henry Hunt Clark 1946.412

13. Central America, Panama, International style. *Crocodile Pendant,* AD 400–700. Cast gold; 10.8 x 3.9 cm. Gift of the Hanna Fund 1957.24

14. Central America, Panama, Conte style. *Hunchback Seated on a Stool,* AD 400–900. Ceramic, slip; 24.8 x 15.8 x 23.4 cm. John L. Severance Fund 1998.115

15. Western Tibet, Toling Monastery. *Preaching Sakyamuni,* 1000s. Ink, color, gold on paper; 11.6 x 10.7 cm. John L. Severance Fund 2000.67

16. North America, Southwest, Mogollan Mimbres people. *Bowl,* 1000–1150. Ceramic, slip; diam. 26.7 cm, h. 15.2 cm. Charles W. Harkness Endowment Fund 1930.36

17. South India, Chola period. *Nataraja, Shiva as the King of Dance,* c. 1100. Bronze; 111.5 x 101.7 cm. Purchase from the J. H. Wade Fund 1930.331

18. North America, Southwest, Anasazi people, Tularosa Black-on-White style. *Jar,* c. 1100–1250. Ceramic, slip; h. 29.8 cm, w. 40.1 cm. Purchase from the J. H. Wade Fund 1984.159

19. South America, Peru, Chimú people. *Loincloth,* 1200–1460s. Plain weave; cotton, gauze; 244 x 90 cm. Norman O. Stone and Ella A. Stone Memorial Fund 2005.5.2

20. Syria, Damascus, late Mamluk period. *Bowl,* 1450–1500. Brass, inlaid with silver and gold; diam. 13.2 cm. Purchase from the J. H. Wade Fund 1945.133

21. Laurent Girardin (French, active 1440–1471). *The Trinity,* c. 1460. Oil on wood; 114 x 94.5 cm. Mr. and Mrs. William H. Marlatt Fund 1960.79

22. Albert Bouts (Netherlandish, 1451/55–1549). *The Annunciation,* c. 1480. Oil on wood; 50.2 x 41.5 cm. Bequest of John L. Severance 1942.635

23. Iran. *Detached Folio from a Koran,* 1500s. Ink, gold, colors on paper; 49 x 36.3 cm. Purchase from the J. H. Wade Fund 1924.746.1–2

Joel Shapiro, *Untitled,* 1989 [129]

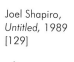

24. Italy. *Needlepoint and Bobbin Lace Table Cover,* 1500–1700. Lace (needlepoint, bobbin); linen; 48.3 x 104.8 cm. Gift of J. H. Wade 1920.1167

25. Albrecht Dürer (German, 1471–1528). *Melencolia I,* 1514. Engraving; 23.8 x 18.6 cm. Gift of Leonard C. Hanna Jr. in memory of Ralph King 1926.211

26. Bernard Palissy and workshop (French, c. 1510–c. 1589). *Oval Dish,* late 1500s. Ceramic, lead glaze; 32 x 24 cm. Purchase from the J. H. Wade Fund 1986.55

27. Germany. *Black and White Morion,* c. 1600. Steel, black paint; 36.3 x 28.6 x 24.4 cm. Gift of Mr. and Mrs. John L. Severance 1916.1080

28. China, Qing dynasty. *The Buddhist Monks of the Obaku Sect,* 1600s. Hanging scroll; ink, color on paper; 171.5 x 99.7 cm. Gift of Mr. and Mrs. Robert T. Gow 2003.352

29. Giovanni Paolo Panini (Italian, 1691–1765). *Interior of the Pantheon, Rome,* 1747. Oil on canvas; 127 x 97.8 cm. Purchase from the J. H. Wade Fund 1974.39

30. France, Chantilly. *Cup and Saucer,* c. 1760–70. Porcelain; diam 7.5 cm (saucer), h. 6 cm (cup). The Norweb Collection 1962.354.a–b

31. Jean-Baptiste II Tilliard (French). *Armchair,* c. 1765. Carved, gilded wood; 101.9 x 73.7 x 63.5 cm. Purchase from the J. H. Wade Fund 1927.423.1

32. Francesco Guardi (Italian, 1712–1793). *Piazza San Marco, Venice,* 1780s. Pen and brown ink, brush and brown wash, with brush and gray wash; 31.3 x 46.5 cm. John L. Severance Fund 1951.83

33. Nakamuro Hochu (Japanese, Edo period). *Waves,* late 1700s–early 1800s. Fan painting mounted as hanging scroll; ink, color, gold on paper; 126.4 x 61.3 cm. John L. Severance Fund 1999.90

34. Africa, Gabon, Kota people. *Reliquary Guardian Figure,* 1800s. Wood, metalwork; h. 61 cm. Purchase from the J. H. Wade Fund 2005.2

35. Africa, Ghana, Asante people. *Soul Washer's Badge,* 1800s. Gold; diam. 9.8 cm. Dudley P. Allen Fund 1935.310

36. Africa, Ghana, Asante people. *Soul Washer's Badge,* 1800s. Gold; 7 x 7.6 x 1.6 cm. James Albert Ford Memorial Fund 1944.290

37. Africa, Ghana, Asante people. *Weight for Measuring Gold: Geometric,* 1800s. Brass; 2.5 x 1.9 x .3 cm. Gift of Georges D. Rodrigues 1969.265

38. Africa, Ghana, Asante people. *Weight for Measuring Gold: Geometric,* 1800s. Brass; 2.4 x 1.4 x 1.2 cm. Gift of Mr. and Mrs. Robert M. Hornung 1962.244

39. Oceania, New Zealand, Maori people. *Fishing Canoe Prow,* 1800s. Wood, inlaid with pearl shell; l. 35.3 cm. The Mary Spedding Milliken Memorial Collection, Gift of William Mathewson Milliken 1967.231

40. Oceania, New Zealand, Maori people. *Treasure Box,* 1800s. Wood, inlaid with abalone shell; diam. 17.2 cm, l. 42.9 cm. The Mary Spedding Milliken Memorial Collection, Gift of William Mathewson Milliken 1961.405

41. India. *Part of a Skirt,* early 1800s–early 1900s. Embroidery; silk thread on silk ground; 75.8 x 46.4 cm. Purchase from the J. H. Wade Fund 1925.516

42. Ando Hiroshige (Japanese, 1797–1858). *Yahagi Bridge at Okazaki (Station 39),* from the series "Fifty-Three Stations of the Tokaido," 1833. Color woodblock print; 23 x 35 cm. Gift of Mrs. Henry S. Upson 1916.939

43. United States, Pennsylvania, Centre County, Union Furnace. *Coverlet,* 1837. Beiderwand weave; cotton, wool; 225 x 221 cm. Gift of Kathryn Stryker Jamieson 2001.246

44. Africa, Democratic Republic of the Congo, Kuba people. *Helmet Mask,* mid to late 1800s. Wood; 43.3 x 31.2 x 28.3 cm. James Albert Ford Memorial Fund 1935.304

45. Eadweard Muybridge (American, 1830–1904). *Emptying a Bucket of Water,* pl. 103 from the book *Animal Locomotion,* 1887. Collotype; 22.5 x 34 cm. Gift of Laurence Miller Gallery, New York, in honor of Evan H. Turner 1992.220

46. Africa, Democratic Republic of the Congo, Kongo people. *Chief's Cap,* late 1800s. Raffia, leopard claws; 42 x 19.3 x 19 cm. John L. Severance Fund 1997.180

47. North America, California, Pomo people. *Storage Bowl,* late 1800s–early 1900s. Twining; plant fiber; 49.9 x 34.6 cm. Presented by William Albert Price in memory of Mrs. William Albert Price 1917.506

48. North America, Northwest Coast, Tlingit people? *Mask,* late 1800s–early 1900s. Wood (alder), pigment; 21 x 17 cm. Purchase from the J. H. Wade Fund 1979.83

49. North America, Southwest, Navajo people. *Hubbell Revival Rug,* c. 1890–1910. Tapestry weave; wool; 194.8 x 138.4 cm. Gift of Mrs. L. E. Holden 1917.62

50. John F. Peto (American, 1854–1907). *Card Rack with a Jack of Hearts,* c. 1895. Oil on canvas; 76.2 x 63.5 cm. Purchase from the J. H. Wade Fund 1973.30

51. Peter Carl Fabergé (Russian, 1846–1920). *Frame with Nine Miniatures,* 1896–1905. Gold, silver gilt; 21.6 x 23.6 cm. The India Early Minshall Collection 1966.460

52. Africa, Democratic Republic of the Congo, Kuba people. *Embroidered Raffia Pile Cloth,* 1900s. Raffia; 59.7 x 64 cm. John L. Severance Fund 1991.224

53. Africa, Democratic Republic of the Congo, Kuba people. *Embroidered Raffia Pile Cloth,* 1900s. Raffia; 57.5 x 48.5 cm. Anonymous gift in honor of the Museum's seventy-fifth anniversary 1992.102

54. Africa, Democratic Republic of the Congo, Kuba people. *Hat,* early 1900s. Raffia, glass beads, cowrie shells, cloth; 29 x 23 x 23 cm. John L. Severance Fund 1998.29

55. Africa, Mali, Bamana people. *Antelope Headdress,* early 1900s. Wood, metal, beads, shells, string; 45.2 x 4.8 x 12.4 cm. Gift of Katherine C. White 1962.307

56. Designed by Frank Lloyd Wright (American, 1867–1959); made at Linden Glass Co. (American). *Casement Window,* c. 1904. Leaded glass panes, metal frame; 105.1 x 28.5 cm. Purchase from the J. H. Wade Fund 1984.11

57. Manierre Dawson (American, 1887–1969). *Differential Complex,* 1910. Oil on board; 40.7 x 31.8 cm. Mr. and Mrs. William H. Marlatt Fund 2001.123

58. Marsden Hartley (American, 1877–1943). *Military,* 1914–15. Oil on canvas; 60.6 x 50.2 cm. Gift of Professor Nelson Goodman 1981.83

59. Edward Wadsworth (British, 1889–1949). *Illustration (Typhoon),* 1914–15. Woodcut; 29 x 25.4 cm. John L. Severance Fund 1987.50

60. Alvin Langdon Coburn (British, 1882–1966). *Vortograph,* 1917. Gelatin silver print; 20.2 x 26.4 cm. Andrew R. and Martha Holden Jennings Fund 2004.33

61. Kurt Schwitters (German, 1887–1948). *Little Dance,* 1920. Collage; 23 x 17 cm. Contemporary Collection of The Cleveland Museum of Art 1963.1

62. John Taylor Arms (American, 1887–1953). *Gates of the City,* 1922. Etching, aquatint; 21.5 x 20.3 cm. Anne Elizabeth Wilson Memorial Fund 1996.8

63. George Grosz (German, 1893–1959). *Student (Costume Study for Goll's "Methusalem"),* 1922. Pen, brown-black ink (applied with drafting tools), watercolor; 52.7 x 38 cm. Contemporary Collection of The Cleveland Museum of Art 1966.50.a

64. Wassily Kandinsky (Russian, 1866–1944). *Small Worlds: VI,* 1922. Woodcut; 27.3 x 23.3 cm. Mr. and Mrs. Charles G. Prasse Collection 1957.203

65. Louis Lozowick (American, 1892–1973). *New York,* 1923. Lithograph; 29 x 22.9 cm. John L. Severance Fund 1997.141

66. El Lissitzky (Russian, 1890–1941). *Plastic Figures of the Electro-Mechanical Show; Victory over the Sun: Globetrotter in Time,* 1923. Lithograph; 53.5 x 45.7 cm. Dudley P. Allen Fund 1991.25

67. Paul Strand (American, 1890–1976). *Lathe, Akeley Shop, New York,* 1923. Gelatin silver print; 24.4 x 19.3 cm. Leonard C. Hanna Jr. Fund 1984.34

68. Georgia O'Keeffe (American, 1887–1986). *Morning Glory with Black,* 1926. Oil on canvas; 91 x 75.5 cm. Bequest of Leonard C. Hanna Jr. 1958.42

69. Jaromír Funke (Czech, 1896–1945). *Composition,* 1927–29. Photogram; gelatin silver print, silver bromide; 38.2 x 27.7 cm. John L. Severance Fund 1986.38

70. Imogen Cunningham (American, 1883–1976). *Black and White Lilies III,* c. 1928. Gelatin silver print; 23.7 x 19 cm. Severance and Greta Millikin Purchase Fund 2001.90

71. Hiromu Kira (American, 1898–1991). *Circles Plus Triangles,* c. 1928. Gelatin silver print; 24.6 x 32.8 cm. John L. Severance Fund 1998.162

72. Theodore Roszak (American, 1907–1981). *Untitled,* c. 1932–39. Photogram; gelatin silver print; 13.9 x 10.9 cm. John L. Severance Fund 1989.396

73. Ilse Bing (American, 1899–1998). *Paris Windows with Flags, Bastille Day,* 1933. Gelatin silver print; 22.3 x 28.2 cm. The A. W. Ellenberger Sr. Endowment Fund 1990.87

74. Alfred Stieglitz (American, 1864–1946). *Georgia O'Keeffe's Hand and Wheel,* 1933. Gelatin silver print; 24.2 x 19.2 cm. Gift of Cary Ross, Knoxville, Tennessee 1935.99

75. Paul Outerbridge (American, 1896–1958). *Cheese and Crackers,* 1936. Assembly process color print (three-color carbro process); 36.6 x 28.6 cm. Gift of Mrs. Ralph S. Allen 1942.1165

Colombia, Central Highlands, Tolima people, *Figure Pendant,* AD 100–700 [10]

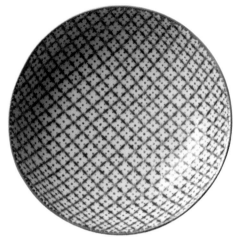

France, Chantilly,
Saucer, c. 1760–70
[30]

76. Edward Weston
(American, 1886–
1958). *Dunes,
Oceano,* 1936.
Gelatin silver print;
19.1 x 24 1 cm.
Severance and Greta
Millikin Purchase Fund
2001.92

77. Theodore Roszak
(American, 1907–
1981). *First Study for
Vertical Construction,*
1939. Plastic, painted
wood; 61.8 x 32.4 x
10.2 cm. Gift of the
Cleveland Society for
Contemporary Art in
honor of Dr. and Mrs.
Sherman E. Lee
1983.159

78. Joan Miró
(Spanish, 1893–1983).
*Woman with Blond
Armpit Combing Her
Hair by the Light of the
Stars,* 1940.
Watercolor, gouache
over graphite; 37.9 x
45.8 cm.
Contemporary
Collection of The
Cleveland Museum of
Art 1965.2.a

79. Grant Wood
(American, 1892–
1942). *January,* 1940.
Oil on masonite panel;
45.7 x 60.1 cm.
Purchase from the J. H.
Wade Fund 2002.2

80. Theodore Roszak
(American, 1907–
1981). *White and Steel
Polars,* 1945. Painted
wood, steel, iron,
plexiglass; 271.8 x
40.6 x 40.6 cm.
Leonard C. Hanna Jr.
Fund 2005.144

81. Brett Weston
(American, 1911–
1993). *Dunes and
Mountains, White
Sands,* 1945. Gelatin
silver print; 19.4 x
24.6 cm. John L.
Severance Fund
1986.32

82. Arthur Siegel
(American, 1913–
1978). *Photogram #9,*
c. 1946. Photogram,
gelatin silver print;
35.2 x 27.9 cm. John
L. Severance Fund
1995.242

83. Alexander Calder
(American, 1898–
1976). *Two Systems,* c.
1946. Aluminum sheet,
iron wire, paint; 45.8 x
160 x 198 cm. Gift of
Mrs. Odette
Valabrègue Wurzburger
in memory of her late
husband, Paul D.
Wurzburger 1999.194

84. Arnold Newman (American, b. 1918). *Igor Stravinsky,* 1946, printed early 1950s. Gelatin silver print; 24.5 x 47.6 cm. John L. Severance Fund 1992.53

85. Victor Vasarely (French, 1908–1997). *Lom-Lan,* 1949–52. Oil on canvas; 92 x 59.8 cm. Contemporary Collection of The Cleveland Museum of Art 1965.427

86. Fritz Glarner (American, 1899–1972). *Tondo, No. 12,* 1949. Oil on Masonite panel; diam. 34.4 cm. Contemporary Collection of The Cleveland Museum of Art 1967.4

87. Jacob Lawrence (American, 1917–2000). *Creative Therapy,* 1949. Casein over graphite; 56 x 76.4 cm. Delia E. Holden Fund 1994.2

88. Charmion von Wiegand (American, 1896–1983). *Power Plant II,* 1949. Oil on canvas; 50.9 x 61 cm. Dorothea Wright Hamilton Fund 1982.178

89. Pim van Os (Dutch, 1910–1954). *Geometric Abstraction,* c. 1950. Gelatin silver print; 23.7 x 17.7 cm. John L. Severance Fund 1993.143

90. Louise Bourgeois (American, b. 1911). *Untitled,* c. 1950. Brush and black ink and gray wash, with white paint, traces of black chalk, blue crayon; 55.9 x 71.2 cm. Purchase from the J. H. Wade Fund 1998.112

91. Jackson Pollock (American, 1912–1956). *Number 5,* 1950. Oil on canvas; 136.5 x 99.1 cm. Leonard C. Hanna Jr. Fund 1980.180

92. Aaron Siskind (American, 1903–1991). *New York 3,* 1951. Gelatin silver print; 26.2 x 33.6 cm. Purchased with a grant from the NEA and matched by contributions from Museum members in 1989 1989.468

93. Designed by Frank Lloyd Wright (American, 1867–1959); manufactured by F. Schumacher and Co. (American). *Screen Printed Linen Textile,* 1955. Tabby weave, silkscreen printed; linen; 228 x 122.7 cm. Gift of F. Schumacher and Co. 1955.617

94. Robert Motherwell (American, 1915–1991). *Elegy to the Spanish Republic No. LV,* 1955–60. Oil on canvas; 178.1 x 193.7 cm. Contemporary Collection of The Cleveland Museum of Art 1963.583

95. Josef Albers (American, 1888–1976). *Homage to the Square: Star Blue,* 1957. Oil on board; 75.9 x 75.9 cm. Contemporary Collection of The Cleveland Museum of Art 1965.1

96. Stuart Davis (American, 1894–1964). *Composition Concrete (Study for Mural),* 1957–60. Oil on canvas; 108.6 x 50.8 cm. Contemporary Collection of The Cleveland Museum of Art 1964.2

97. Mark Tobey (American, 1890–1976). *Canals, No. 3, 1958,* 1958. Watercolor, gouache; 30.7 x 23 cm. Gift of Mr. and Mrs. Carl L. Selden 1958.473

98. Harry Callahan (American, 1912–1999). *Grasses, Wisconsin,* 1959. Gelatin silver print; 11.1 x 16.8 cm. Gift of Friends of Photography in honor of Evan H. Turner 1993.129

99. Sonia Delaunay (Russian, 1885–1979). *Untitled,* 1960s–70s. Lithograph; 53.3 x 56.1 cm. Gift of Anne and Robert Levine 1981.162

100. Paul Caponigro (American, b. 1932). *Sunflower Study,* c. 1960. Gelatin silver print; 10.3 x 9.6 cm. Thomas and Mildred Dougherty Foundation 1986.189

101. David Smith (American, 1906–1965). *Untitled (Cubi Study),* 1962. Blue spray paint; 50.5 x 66.2 cm. Purchase from the J. H. Wade Fund 1986.19

102. Burgoyne Diller (American, 1906–1965). *First Theme,* 1963. Oil on canvas; 228.6 x 99 cm. Andrew R. and Martha Holden Jennings Fund 1973.211

103. Adolph Gottlieb (American, 1903–1974). *Untitled,* 1965. Black ink, enamel; 61.2 x 48.4 cm. Edwin R. and Harriet Pelton Perkins Memorial Fund 1987.48

104. Ray K. Metzker (American, b. 1931). *Composites: Philadelphia (Apertures),* 1965. Gelatin silver prints; 36.5 x 57.7 cm. Purchase from the J. H. Wade Fund 1986.93

105. Ralph Gibson (American, b. 1939). *Untitled* (from the series "The Somnambulist"), 1966. Gelatin silver print; 31.9 x 21 cm. Gift of Adam Sutner 1995.258

106. Maria Martinez (American, 1889–1980) and Popovi Da (American, 1921–1971). *Plate,* 1966. Ceramic; diam. 30 cm. Gift of Francis and David Dickenson in memory of Sarah Dickenson and Jeffrey Cudlip 2003.348

107. Richard Anuszkiewicz (American, b. 1930). *Prisma,* 1968. Oil on canvas; 274.3 x 182.8 cm. Gift of Katherine C. White 1977.193

108. Frank Stella (American, b. 1936). *Gray Scramble (Single), VIII,* 1968. Synthetic polymer paint on canvas; 175.2 x 175.2 cm. Anonymous Gift 2003.355

109. Ernest Trova (American, b. 1927); woven by Pinton S. A. (Felleton, France). *Falling Man/Canto T,* 1970s. Tapestry weave; wool and metal foil; 213.3 x 213.3 cm. Gift from the Estate of Gloria F. Ross 1999.207

110. Brice Marden (American, b. 1938). *Sea Painting I,* 1973–74. Oil, wax on canvas; 182.8 x 137.2 cm. Private collection, New York 287.1993

111. Romare Bearden (American, 1914–1988). *Wrapping It Up at the Lafayette,* 1974. Collage, acrylic, lacquer; 121.9 x 91.5 cm. Mr. and Mrs. William H. Marlatt Fund 1985.41

112. Al Held (American, 1928–2005). *Jupiter IV,* 1974. Acrylic on canvas; 152.4 x 152.4 cm. Purchased with a grant from the NEA and matched by gifts from members of The Cleveland Society for Contemporary Art 1976.101

113. Richard Pousette-Dart (American, 1916–1992). *Window of Unknowing,* 1975–76. Oil on canvas; 127 x 181.6 cm. Gift of the Linden Trust 1983.218

114. Manuel Alvarez Bravo (Mexican, 1902–2002). *Two Women, a Large Blind, and Shadows,* from the portfolio *Photographs by Manuel Alvarez Bravo,* 1977. Gelatin silver print; 18.4 x 24.2 cm. Gift of Mr. and Mrs. Louis Stumberg 1985.220.5

115. Jasper Johns (American, b. 1930). *Usuyuki,* 1977–78. Encaustic, collage on canvas; 86.4 x 45.7 cm. Leonard C. Hanna Jr. Fund 1993.109

116. Lia Cook (American, b. 1942). *Landform Red,* 1978. Warp-faced rep weaving; shaped polyurethane weft, rayon thread, plexiglass box; 32.1 x 27 x 3.5 cm. Gift of Mildred Constantine 1992.248

117. Ralph Gibson (American, b. 1939). *Untitled* from "The Black Series," 1980. Gelatin silver print; 31.8 x 21.1 cm. Gift of Museum members in 1989 1989.429

118. William Clift (American, b. 1944). *Vaulted Ceiling, Mont-Saint-Michel, France,* 1982. Platinum/palladium print; 12.1 x 9.5 cm. Anonymous Gift 1990.113

119. Bridget Riley (British, b. 1931). *Elapse,* 1982. Screenprint; 102 x 63.8 cm. Gift of The Print Club of Cleveland 1982.174

120. Designed by Ettore Sottsass (Italian, b. 1917); made at Memphis Firm (Italian). *Fruit Bowl,* 1982. Silver; diam. 39.6 cm, h. 29.3 cm (open and extended). Gift of the Trideca Society 1998.149

121. Brett Weston (American, 1911–1993). *Leaf, Hawaii,* 1982. Gelatin silver print; 30.9 x 27.2 cm. Gift of Russ Anderson 1991.301

122. Mel Bochner (American, b. 1940). *Quarry (Study),* 1983. Oil, enamel; 57 x 77 cm. John L. Severance Fund 1999.19

123. Ellen Carey (American, b. 1952). *Constructivist Portrait,* 1983. Gelatin silver print, toned and painted; 45.7 x 51.5 cm. Gift of Dorothy Handelman 2003.309

124. Hiroshi Seto (Japanese, b. 1941). *Square Vase,* 1984. Stoneware with incised stripe design in silver luster, natural ash glaze; 29.2 x 7.6 x 8.9 cm. Gift of T. Dixon Long 2001.73

125. Dorothea Rockburne (Canadian, active United States, b. 1932). *White Mozart,* 1986. Prismacolor on folded paper; 100.5 x 61.5 cm. Gift of Agnes Gund 1988.26

126. Dorothea Rockburne (Canadian, active United States, b. 1932). *White Mozart, Upside Down and Backwards,* 1986. Prismacolor on folded paper; 100.5 x 61.5 cm. John L. Severance Fund 1988.27

127. Sol LeWitt (American, b. 1928). *Working Drawings for "Continuous Forms,"* 1987. Graphite on two sheets; 92 x 61 cm. Gift of the Artist 1987.106.a–b

128. Hiroshi Sugimoto (Japanese, b. 1948). *Caribbean Sea, Jamaica,* 1988. Gelatin silver print; 42.1 x 54.5 cm. Gift of Mrs. A. Dean Perry, Mrs. John B. Dempsey, and Mr. Donald F. Barney Jr. in honor of Brenda and Evan Turner 1994.22

129. Joel Shapiro (American, b. 1941). *Untitled,* 1989. Bronze; 177.8 x 203.2 x 76.2 cm. Leonard C. Hanna Jr. Fund 1989.57

130. Sam Gilliam (American, b. 1933). *Untitled,* 1991. Oil on Japanese paper; 56.6 x 82.2 cm. Gift of Ernie Cahoon in memory of Nina Winkler and Elizabeth Christian 2001.180

131. Sol LeWitt (American, b. 1928). *24C,* 1991. Painted wood; 279.4 x 61.9 x 62.9 cm. Gift of Shuree Abrams, by exchange 1994.21

Germany, *Black and White Morion,* c. 1600 [27]

132. Richard Long (British, b. 1945). *Cornwall Circle,* 1991. Slate; diam. 540 cm. Seventy-fifth anniversary gift of the Cleveland Society for Contemporary Art on the occasion of its Thirtieth Anniversary 1991.111

133. Sean Scully (American, b. 1945). *Planes of Light,* 1991. Woodcut; 84.4 x 112.5 cm. Seventy-Fifth Anniversary Gift of Pamela Pratt Auchincloss and Garner H. Tullis 1991.183

134. Helen Naha (American, 1922–1993). *Vessel,* before 1993. Ceramic; diam. 35.1 cm, h. 15 cm. Gift of Francis and David Dickenson in memory of Sarah Dickenson and Jeffrey Cudlip 2003.347

135. Carrie Mae Weems (American, b. 1953). *Untitled,* 1993. Triptych, gelatin silver prints; 50 x 148.8 overall cm. John L. Severance Fund 2000.89.a–c

136. Martin Puryear (American, b. 1941). *Alien Huddle,* 1993–95. Red cedar, pine; 134.6 x 162.5 x 134.6 cm. Gift of Agnes Gund and Daniel Shapiro 2002.65

137. Guillermo Kuitca (Argentinean, b. 1961). *Crown of Thorns (Songs on the Death of Children),* 1994. Acrylic on canvas; 240 x 189.8 cm. Gift of the Contemporary Art Society on the occasion of its 40th Anniversary 2000.21

138. Nancy Youngblood Lugo (American, b. 1955). *Carved Vessel,* 1994. Ceramic; diam. 22.6 cm, h. 15 cm. James Albert and Mary Gardiner Ford Memorial Fund 1994.199

139. Robert Mangold (American, b. 1937). *Curved Plane/Figure VII (Study),* 1995. Acrylic, graphite on canvas, on three stretchers joined to form a lunette; 124.5 x 248.9 cm overall. Gift of the Cleveland Society for Contemporary Art on the occasion of its 35th anniversary 1995.171.a–c

140. Hiroshi Sugimoto (Japanese, b. 1948). *Hall of Thirty-Three Bays,* 1995. Gelatin silver print; 42.5 x 54.3 cm. Gift of Mr. Donald F. Barney Jr. in memory of Helen Greene (Mrs. A. Dean) Perry 1998.116

141. Chuck Close (American, b. 1940). *Paul III,* 1996. Oil on canvas; 259.6 x 213.5 cm. Mr. and Mrs. William H. Marlatt Fund 1997.59

142. Terry Winters (American, b. 1949). *Application Domains (11),* 1997. Graphite; 45.5 x 56.7 cm. John L. Severance Fund 1998.33

143. Ellen Gallagher (American, b. 1965). *Bouffant Pride,* 2003. Collage; cutout, painting, photogravure on rag paper; 34.3 x 25.5 cm. Mr. and Mrs. James A. Saks Fund 2003.340

Figure List

Credits

Works of art in the collection of the Cleveland Museum of Art were photographed by museum photographers Howard Agriesti and Gary Kirchenbauer; the photographs are copyright by the Cleveland Museum of Art. Copyright in the United States or abroad on the works of art themselves may also be retained by the artists, their heirs, successors, and others. The following are acknowledged: cover and p. 115: © Ellen Carey; title page and p. 64 (bottom): © Artists Rights Society (ARS), New York/VG Bild-Kunst, Bonn; copyright page, pp. 76 (right), and 77: © Frank Stella/Artists Rights Society (ARS), New York; p. 17: Estate of Fernand Léger © Artists Rights Society (ARS), New York; p. 23 (top): Howard Agriesti; p. 23 (right): Sébastien Bertrand, Paris; p. 26 (bottom): © Dorothea Rockburne/Artists Rights Society (ARS), New York; p. 27: © The Jacob and Gwendolyn Lawrence Foundation, Seattle/Artists Rights Society (ARS), New York; p. 28 (top): © Richard Long, 2006, courtesy: Haunch of Venison, London; p. 29 (left): © Artists Rights Society (ARS), New York/ADAGP, Paris; p. 41 (right): © Frank Lloyd Wright Foundation, Scottsdale, AZ/Artists Rights Society (ARS), New York; p. 47: © Robert Mangold/Artists Rights Society (ARS), New York; p. 49: drawings by Thomas H. Barnard III; p. 58 (right): © Artists Rights Society (ARS), New York/ADAGP, Paris; p. 59 (left): © Artists Rights Society (ARS), New York/ADAGP, Paris; p. 60 (top right): © Artists Rights Society (ARS), New York/DACS, London; p. 61: © courtesy the Estate of Louis Lozowick and Mary Ryan Gallery, New York; p. 62: © Artists Rights Society (ARS), New York/ADAGP, Paris; p. 63 (right): © Artists Rights Society (ARS), New York/VG Bild-Kunst, Bonn; p. 66 (left): © 2001 Mondrian/Holtzman Trust; p. 70 (right) and 71 (left): © The Georgia O'Keeffe Foundation/Artists Rights Society (ARS), New York; pp. 51 (all) and 74 (right): © Sol LeWitt/Artists Rights Society (ARS), New York; p. 75: © Brice Marden/Artists Rights Society (ARS), New York; p. 76 (left): © The Josef and Anni Albers Foundation/Artists Rights Society (ARS), New York; p. 81 (left): © Artists Rights Society (ARS), New York/ADAGP, Paris; p. 89 (left): © Ettore Sottsass; p. 96 (left): © Estate of Ilse Bing, courtesy Edwynn Houk Gallery, New York; pp. 97 (top) and 105: © Ray K. Metzker, courtesy Laurence Miller Gallery, New York; p. 100 (left): © Estate of Hans Hofmann/Artists Rights Society (ARS), New York; p. 100 (right): © The Pollock-Krasner Foundation/Artists Rights Society (ARS), New York; p. 103 (top): © Successió Miró/Artists Rights Society (ARS), New York/ADAGP, Paris; p. 103 (bottom): © Estate of Alexander Calder/Artists Rights Society (ARS), New York; p. 116: © Joel Shapiro/Artists Rights Society (ARS), New York.

Guillermo Kuitca, *Crown of Thorns*, 1994 [137]

Tailpiece: Albrecht Dürer, *Melencolia I* (detail), 1514 [25]

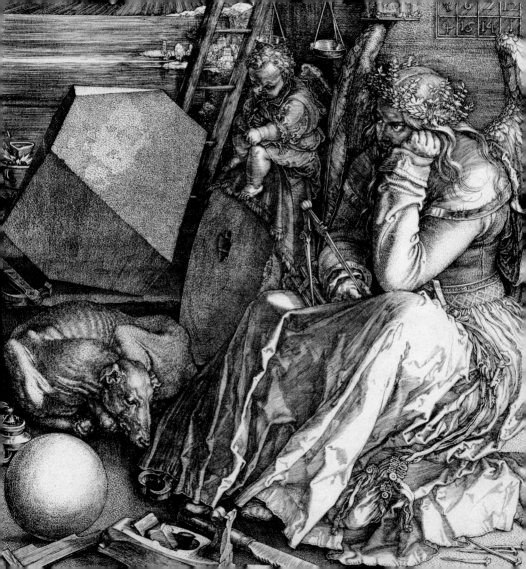